Hogarth

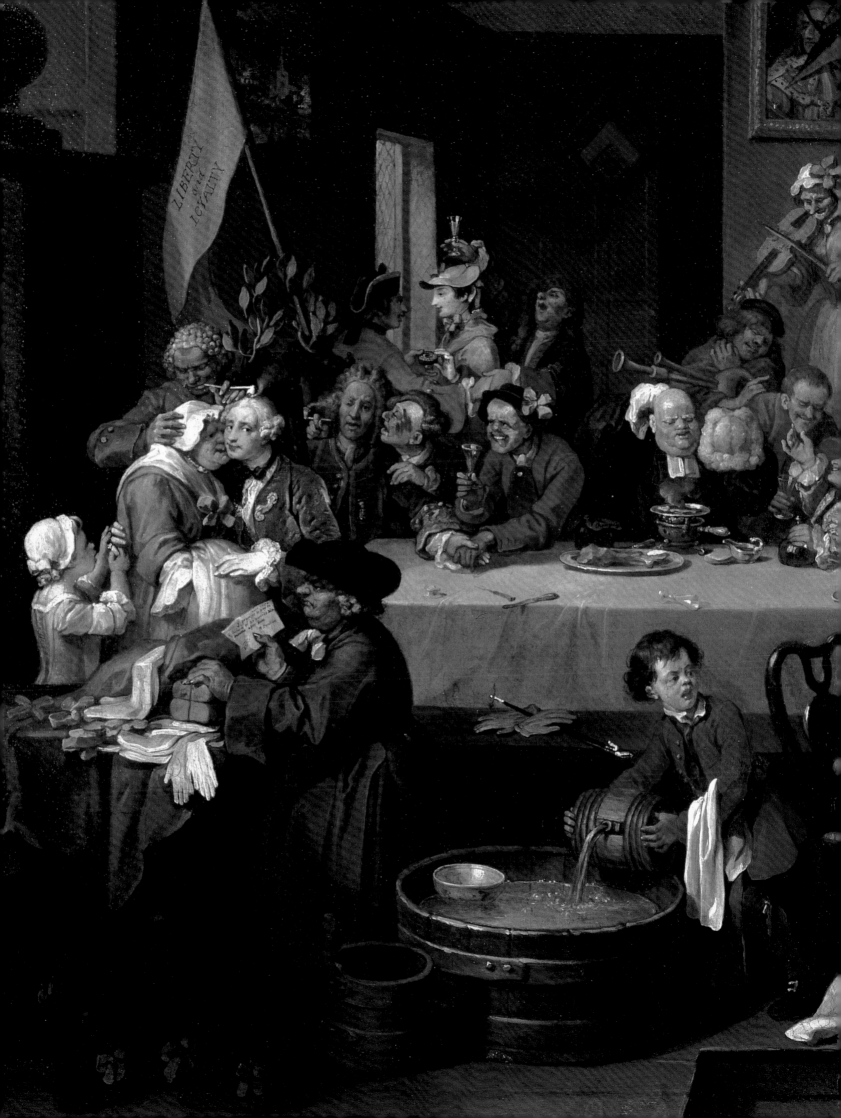

Hogarth's Variety

Mark Hallett

In the spring of 1753 William Hogarth published *The Analysis of Beauty*, an aesthetic treatise in which he offered his own, highly original interpretation of beauty's formal characteristics. The title page of the *Analysis* is decorated with a small wood engraving, which offers a visual synopsis of his theories (fig.1). This pictorial vignette depicts a snake trapped in a pyramid of glass standing on a plinth inscribed with the single word, 'VARIETY'. While the curve of the snake's body embodies the twisting, serpentine line that the artist saw as central to all forms of beauty, and the pyramid of glass refers to a classical ideal of perfect proportion, the inclusion of the word 'variety' signals the crucial role granted to this concept by the artist. Indeed, a chapter of the *Analysis* is entitled 'On Variety', and in it Hogarth argues that 'composed variety' is a vital component of beauty and points to the way in which nature itself is full of shapes and colours geared to 'entertaining the eye with the pleasure of variety'.[1]

As he was fully aware, the term 'variety' was also highly applicable to the remarkably diverse body of paintings and engravings that he himself had produced over the previous thirty years or so, and that he was to continue to generate until his death in 1764. Indeed, the word was one that eighteenth-century writers regularly used to describe the artist's work. Early in Hogarth's career, in the 1730s, the poet John Bancks was already lauding the 'varied grace' of the artist's imagery, and George Vertue, a successful engraver who was also an assiduous commentator on the London art scene, was noting the 'great variety' of Hogarth's pictures.[2] In the years following the artist's death, the same terms of praise were still being used to describe his output: in 1768, for example, William Gilpin celebrated the

Marriage A-la-Mode: 4, *The Toilette* 1743–5 (no.77, detail)

FIGURE 1
The Analysis of Beauty 1753 (title page)
ANDREW EDMUNDS, LONDON

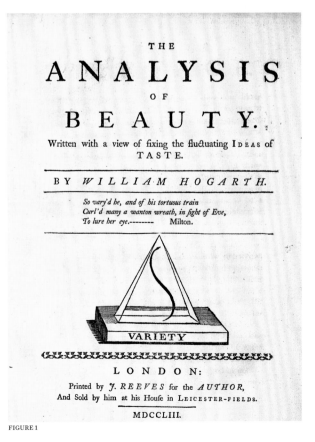

FIGURE 1

FIGURE 2
The Analysis of Beauty 1753
Plate 1 '*The Sculptor's Yard*'
ANDREW EDMUNDS,
LONDON

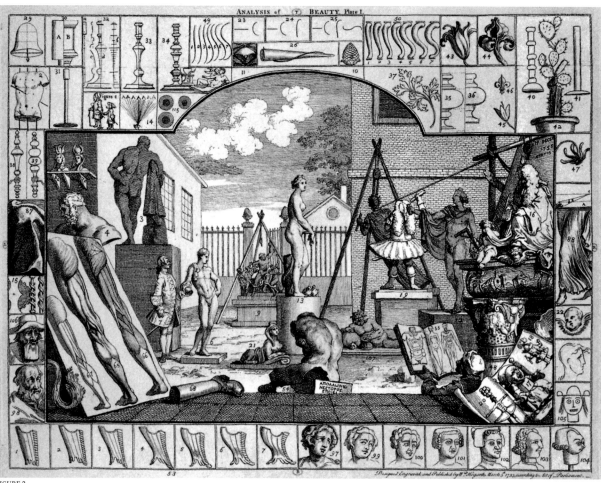

FIGURE 2

'endless variety that is displayed through Hogarth's works'.[3]

The images with which the artist illustrated the *Analysis of Beauty* – described by one writer as making up a 'variety of entertaining engravings' – suggest why the artist was understood in this way.[4] As well as designing the pictorial vignette on the treatise's title page, Hogarth produced two prints to accompany the *Analysis*, which he advertised as 'serious and comical' works of art in their own right, 'fit to frame for furniture'[5] (fig.2, no.6). They picture, respectively, a sculptor's jumbled yard and an assembly of eager dancers, and share a diagrammatic pictorial border that in both cases is dense with heterogeneous images. In the first of Hogarth's two plates a collection of classical statues, a wooden leg, a foppish gentleman and a miscellany of anatomical illustrations and caricatures are juxtaposed with a series of corsets, a succession of flowers, a cluster of candlesticks, a children's drawing and even a cactus! In the other the graceful and awkward bodies of numerous dancers flit past a medley of portraits, while the pictorial border displays a crowd of faces, a series of shells and a trio of rippling torsos. These two engravings, as well as illustrating the key concepts of Hogarth's text, clearly revel in the visual pleasures and artistic possibilities of pictorial variety.

A glance at the kinds of work the artist was creating in the years immediately before the publication of the *Analysis* dramatically confirms the extent to which Hogarth's 'variety' encompassed not only the visual character of his images but also the kinds of art he produced. In February 1751, for instance, Hogarth published his famous print *Gin Lane* (no.98), a horrific social satire in which anonymous, poverty-stricken alcoholics, their features depicted in the boldest of engraved lines, sprawl, fight and die among the ruins of a collapsing city. At the print's centre a monumental, stupefied and disease-ridden drunk pinches snuff as her wizened child spills into the bowels of a subterranean gin-cellar. Yet only a year later, in February 1752, Hogarth published an engraving after his picture of *Moses Brought to Pharaoh's Daughter* (no.107), which flaunted his achievements in the very different, far more elevated genre of history painting. In this image he focuses on a pair of idealised biblical figures – the cherubic, anxious figure of Moses and the beautiful, luxuriously clothed daughter of a pharaoh – who are placed in an exotic Egyptian palace and drawn into a tender narrative of benevolence that is in utter contrast to the drama of maternal neglect found at the centre of *Gin Lane*.

The artist who so successfully moved between different genres in this way, and who was seen to generate a stream of images of an unparalleled visual variety as he did so, had long been recognised by his peers as the most important English painter and engraver of his time. Hogarth's reputation as an exceptionally original and inventive artist who was profoundly responsive to the social and cultural developments of his era has continued to grow.

Today, he tends to be appreciated in particular as a great satirist, someone who offered an acidic and sometimes comic vision of a society mired in corruption and hypocrisy, and who told remarkable pictorial stories about the flawed and ill-fated individuals – prostitutes, rakes, alcoholics, yokels, thieves and murderers – who lived and died outside the boundaries of respectable society.

What is less often recognised is that Hogarth's brilliance as a satirist was only one part of his achievements. He was also – as we have already begun to see – an unusually innovative and ambitious figure in a number of other artistic fields, including those of portraiture, history painting and art theory. Not only this, Hogarth was hugely important in helping to promote contemporary British painting and engraving as art forms that could successfully stand comparison with the greatest works being produced on the continent. To begin understanding this rich artistic legacy, we need to get a better sense of Hogarth's life and career, of the diverse visual culture to which he belonged, and of the heterogeneous city in which he lived.

William Hogarth was born on 10 November 1697 in a small house in Bartholomew Close, just off Smithfield meat market in the City of London. He was thus very much a Londoner, part of a metropolis that was continually growing throughout his lifetime and that – by the time of his death in 1764 – was the largest city in Europe, with a population of nearly three-quarters of a million.[6] Over this same period the English capital developed a strikingly bifurcated identity. The City of London in the east maintained its strongly mercantile and financial character, while also becoming increasingly associated with the poverty and crime that characterised a number of its grimmer districts. On the other side of the capital London's 'West End' – part of the old City of Westminster – came to enjoy a fashionable and genteel status as a residential quarter for an increasingly urbanised aristocratic elite. This was the era of the West End square, where the 'Quality' lived during the winter season. The centre of London, meanwhile, became busy with the enterprises that serviced the cultural needs of the West End elite and also catered to the capital's increasingly influential and self-consciously 'polished' community of professionals and affluent tradesmen. Areas such as Covent Garden, St Martin's Lane, Charing Cross and the Strand were full of printshops, clothes shops, jewellers, theatres, bookshops, artist's showrooms, auction houses, coffee shops and music rooms. Even in these commercially dynamic sectors of the city, however, there were pockets of great deprivation and squalor, including the slums of St Giles pictured in *Gin Lane*. Eighteenth-century London, as Samuel Johnson observed, was a place of 'wonderful extent and variety', and its unique mixture of environments and activities generated an exceptionally vibrant urban culture – one that Hogarth was to depict and draw upon continually in his art.[7]

Hogarth grew up in the East End, and his childhood was unstable and often troubled. His father Richard Hogarth had moved to the capital in the 1680s and married the artist's mother Anne in 1690. Richard was a scholarly man of modest social status who sought to make his way as a schoolmaster, a linguist and an author. In a rather improbable venture he also opened a coffee house in which customers were encouraged to speak Latin. Catastrophically, but perhaps unsurprisingly, Richard was arrested for debt in the winter of 1707/8, and he and his family, which by this time included his daughters Anne and Mary as well as his ten-year-old son William, were suddenly forced to live in debtor's lodgings near the infamous Fleet Prison. They were to remain there for four miserable years, before being set free in 1712 following the passage of a parliamentary Insolvent Debtors Bill that provided relief for such families. Richard, who continued to dream of success as a man of letters, was never to enjoy the fruits of his scholarship. He died in 1718, leaving behind a son who, now a young adult, remained forever embittered about the manner in which his father had been betrayed by the aristocrats who had falsely promised him patronage, and by the tradesmen who had continually exploited his intellectual gifts. His father's harrowing example haunted Hogarth throughout his life and undoubtedly fuelled the astonishing determination with which he pursued his artistic enterprises.

As a child, Hogarth demonstrated considerable artistic precocity, and by the time of his father's death, he had already spent four years as an apprentice to the Westminster-based silver-plate engraver, Ellis Gamble. There he learnt the rudiments of accurately inscribing metal with the sharp engraver's instrument known as a burin. In 1720, however, he broke off his apprenticeship with Gamble and set up shop as an independent copperplate engraver. Over the next decade, during which he settled down in the centre of the city, the young artist produced a wide range of graphic works that included book illustrations, trade cards and theatrical benefit tickets. Most importantly of all, he designed a succession of increasingly ambitious pictorial satires that targeted the excesses and fashions of urban life. In doing so, he drew on a rich graphic tradition, for throughout the previous hundred years artists and print-publishers had regularly published satirical prints commentating on social, political and cultural affairs.[8] This tradition was newly invigorated in the early decades of the eighteenth century, when pictorial satire came to be appreciated as one of the most ambitious, experimental and complex forms of contemporary printmaking.[9] Hogarth played a central role in this development, and in the 1720s began crafting a distinctively satiric image of the modern city as a delusional and fragmented environment overrun by swarming crowds of individuals in thrall to a multiplicity of perverse desires and attractions.

Even as he gained recognition for his abilities as a graphic satirist, Hogarth was already turning to the parallel sphere of painting. In 1720 he enrolled in the newly founded Academy of Painting in St Martin's Lane, run by the French history painter Louis Cheron

and the English artist John Vanderbank.[10] There he was given the opportunity to develop his skills in a medium that had traditionally enjoyed a higher aesthetic and cultural status than graphic art and was being practised by a diverse group of practitioners. It has been too rarely noted that London's art world in the first decades of the eighteenth century was strikingly cosmopolitan. In the absence of an established school of British painting or any binding forms of guild protection, the community of painters living and working in London was strongly European in character. Painters born in France, Italy, Germany and the Low Countries enjoyed an unusual prominence and provided a highly stimulating example for native artists like Hogarth both to emulate and to compete against.[11] Typically based in the area around Covent Garden (no.58), the immigrant painters and engravers brought with them the habits, skills and preoccupations that marked the continental art worlds from which they had emerged. Hogarth, who by the middle of the 1720s was living close to Covent Garden, could not fail but be inspired by their works and by the opportunity that the St Martin's Lane Academy, and the artist-frequented taverns and coffee shops of the district, provided to discuss and debate the role of painting in modern Britain.

Evidently eager to develop his skills, Hogarth also seems to have become involved in another artist's academy in the 1720s, that run from his Covent Garden house by James Thornhill, whose distinguished career as a history painter provided a celebrated if unusual instance of a British artist who had successfully competed with his foreign-born rivals.[12] Hogarth's attendance at Thornhill's Academy brought other benefits, for there the young artist met Thornhill's daughter Jane, whom he married in 1729 after an elopement. Their relationship seems to have developed into a stable and mutually supportive one, with Jane becoming, alongside Hogarth's unmarried sisters Anne and Mary, part of an intimate, familial circle of women with whom he felt at ease and to whom, throughout his life, he felt responsible. Significantly, his marriage to Jane proved childless, which seems to have given added impetus to Hogarth's later, highly energetic and clearly heartfelt involvement in Thomas Coram's Foundling Hospital for abandoned children.

By the time he married Jane, Hogarth was confident enough as a painter to have begun producing small satirical canvases. His breakthrough in the medium came, however, with a series of pictures he painted between 1728 and 1731 depicting a scene from the great theatrical success of the period, John Gay's *The Beggar's Opera* (nos.38–9). Gay's mock opera offered a satirical, humorous and sometimes sympathetic representation of the underside of urban life and featured highwaymen, prostitutes, corrupt lawyers and brutal gaolers among its colourful cast of low-life characters. Hogarth's responses to this work see him developing his abilities as a painter and producing canvases that are marked by an increasingly confident and intricate orchestration of figures across pictorial space. Their success – one was bought by John Rich, the impresario

who had first staged *The Beggar's Opera* – emboldened the artist to produce the first of what he later described as his 'modern moral subjects': *A Harlot's Progress* (no.43).[13]

This series of six paintings and prints was displayed to the public in the Covent Garden house of Hogarth's father-in-law James Thornhill in the spring of 1732. It offered a remarkably novel, multi-layered and compelling depiction of a fictional prostitute's doomed journey through the streets, apartments, prisons and garrets of London. Hogarth's pictorial series was a critical and commercial sensation, and was lauded as a work that combined a satiric form of moral commentary with the richest kinds of visual pleasure. In the words of an address to the artist by the contemporary poet John Bancks, 'Thy *Harlot* pleas'd and warn'd us too – | What will not gay instruction do?'[14] As well as bringing him instant artistic celebrity, *A Harlot's Progress* brought Hogarth new-found wealth. Thanks to the profits he made from the sale of the engravings of the series, Hogarth and his wife were able to move from the bohemian but increasingly disreputable area of Covent Garden to a house in the more fashionable West End square of Leicester Fields. Hogarth was soon to produce two more celebrated pictorial series from this location: *A Rake's Progress* (no.44) and *The Four Times of Day* (no.67). These two works, while maintaining the *Harlot's* focus on the more dubious and hypocritical figures of urban society, also demonstrate the development of his vision of London as a space of contrast, flux and overflow. Furthermore, they confirmed his increasing mastery of the series as a pictorial format: in both cases meaning and narrative are generated not only by a highly innovative manipulation of figures, architecture and space within individual paintings and engravings, but also by the subtle pictorial relationships that he sets up between the different images that make up each series.

At the same time as he was enjoying great success as a creator of a new, satirical imagery of metropolitan life, Hogarth was also producing another highly innovative kind of modern painting. Throughout the 1730s the artist executed a series of the modestly scaled group portraits that contemporaries called 'conversation pieces'. These typically showed gatherings of men and women enjoying the kinds of convivial activity – drinking tea, playing cards, admiring works of art and pursuing the pleasures of conversation – that were being promoted as central to the increasingly fashionable practice of polite sociability. In these paintings Hogarth subtly explores and illuminates the relationships between the men, women and children of a new social elite made up not only of the aristocracy but also of families whose wealth came from the worlds of finance and commerce. These pictures are organised around an exquisitely choreographed succession of looks and gestures, in which the turn of a head, the pointing of a finger, the overlap of one body against another, even the resting of a hand on a chair-back, become pregnant with meaning and possibility. Hogarth's conversation pieces provided an important

counterpoint to the artist's riotous, low-life satires, offering as they did an ideal of restrained, elegant and inclusive social interaction, played out in the most decorous of settings. This was a pictorial ideal with which Hogarth's elite patrons could comfortably identify, and which his supporters could point to as evidence of the artist's ability to produce the most refined as well as the most raucous of images.

In yet another confirmation of the variety and ambition of Hogarth's output this same period also saw him turning to history painting, a pictorial genre that demanded a learned pictorial response to the great texts of literature, history, religion and mythology. The British cultural elite, who tended to associate history painting with the works of continental Old Masters, had hitherto regarded success in the genre as beyond the talents of any living English artist; the recognition enjoyed by Hogarth's father-in-law James Thornhill in the early decades of the century was the exception that proved the rule. Seeking to confound such prejudices, the artist produced a pair of remarkable paintings of scenes from Milton and Shakespeare in the early 1730s (nos.103, 104). Then, in 1736 and 1737 he installed two enormous historical canvases in the newly extended St Bartholomew's Hospital in London, both of which depicted biblical episodes of a suitably charitable and medical nature. *The Pool of Bethesda* (see fig.38) and *The Good Samaritan* (fig.3) are monumental pictures that continue to hang in the grand stairwell for which they were painted. These works, while alluding to earlier treatments of both subjects by continental Old Masters, offer a radical mode of history painting in which the idealised figures and storylines associated with the genre are brought into disturbingly intimate contact with those of a lower, often quite grotesque character.

Throughout his later career Hogarth was to pursue and develop this adventurous and often controversial agenda for history painting.

Alongside his professional activities as a painter and engraver during the 1730s, Hogarth became heavily involved in the teaching of art. Following Thornhill's death in 1734, Hogarth inherited the equipment of his father-in-law's old academy and set up a new Academy of Painting at St Martin's Lane in London. Over the next twenty years this was to provide an important artistic centre in the capital. At Hogarth's Academy established and aspiring artists regularly gathered together to draw from the living model and to learn from the example of a series of distinguished teachers, both native and foreign. Hogarth ran the Academy on unusually egalitarian and informal lines: there was no rigid distinction made between governors and pupils, and there were few prescriptions regarding the ways in which the model might be posed or drawn – indeed, subscribers were allowed, in turn, to 'place the man or woman in such attitude, in the middle of the room, as suits their fancy'.[15] Copying from other artworks was frowned on; instead, stress was placed on observation and on the subtly varied 'prospects' of the model enjoyed by the students as they sat in their different seats around the drawing room. Here, then, Hogarth's ideal of 'composed variety' was inculcated at the level of pedagogy as well as in theory and practice.

Having become established as the leading satirist, history painter and painter of conversation pieces in the capital, Hogarth, at the beginning of the 1740s, made a sustained attempt to become similarly successful within the highly competitive sphere of portraiture. In this decade, following the completion of his spectacular portrait of Thomas Coram (no.84), a mercantile

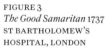

FIGURE 3
The Good Samaritan 1737
ST BARTHOLOMEW'S
HOSPITAL, LONDON

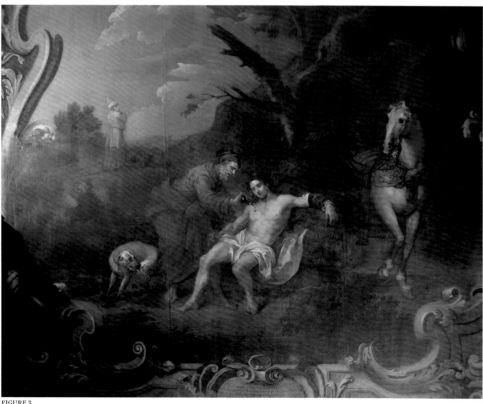

FIGURE 3

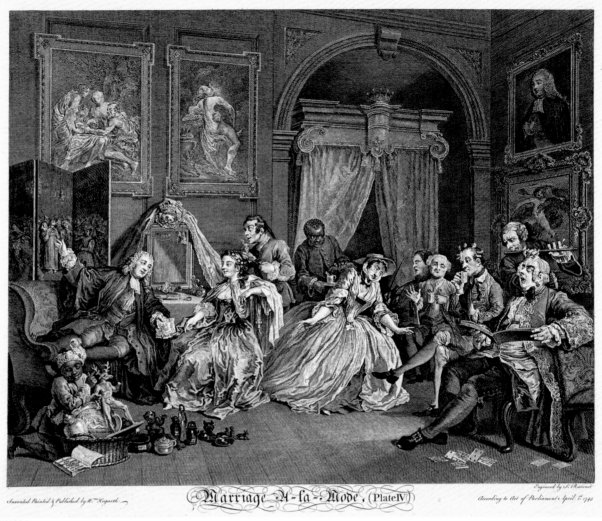

FIGURE 4

philanthropist who had recently set up a celebrated hospital for foundling children, Hogarth produced a succession of ambitious portraits. In these works the artist typically manipulates the lineaments of the face, the gestures of the body, the surfaces of costume, and the tones and textures of paint in order to communicate the values and aspirations of an increasingly confident and self-consciously patriotic community of non-aristocratic men and women. In so doing, Hogarth continually challenged the practices and expectations of his peers and – in the case of masterpieces such as *The Graham Children* (no.93) and *Archbishop Thomas Herring* (no.92) – infused British portraiture with a new degree of emotional depth and pictorial subtlety.

As well as concentrating on portraiture, during the 1740s Hogarth returned to and reformulated the satirical pictorial series. Between 1743 and 1745 he worked on *Marriage A-la-Mode* (no.77), a searing pictorial critique of foreign art and fashion, aristocratic affectation, bourgeois aspiration and arranged marriage. *Marriage A-la-Mode* was also characterised by a new level of pictorial complexity and stylistic elegance. Painted in an exquisitely polished manner, and engraved not by the artist himself but by men whom he described as 'the best Masters in Paris', the series is organised around dizzying forms of pictorial juxtaposition.[16] In an image such as *The Toilette* (fig.4),

for instance, a mass of different representations – the symbolic still lifes that litter the floor, the frieze of figures that spans the picture surface, the painted screen, the draped mirror, the parted curtains of the bed, and the quartet of paintings that hang on the walls – are laid one upon the other. Such works invite an almost archaeological form of visual excavation, in which we can dig deeper and deeper into the dense palimpsest of the pictorial surface. The six paintings of *Marriage A-la-Mode* also contribute to another profound meditation on the English capital, for if we stand back and look at the series as a whole, we find that it offers us a sweeping panorama of contemporary London, which begins in the lavishly appointed West End house of an aristocratic earl and ends in the meanly furnished East End room of a miserly merchant, complete with a view of old London Bridge through its window.

While the prints of *Marriage A-la-Mode* sold well, the enormous amount of money and time that Hogarth had expended on the project encouraged him to change direction yet again. In 1747 he produced another remarkable pictorial series, *Industry and Idleness* (no.97), which offered a sharp contrast to his earlier sets of satirical works, in terms of procedure and scale. Rather than producing a sequence of paintings and then publishing engravings after these canvases, Hogarth engraved his prints directly from preliminary drawn

William Hogarth and Modernity

Frédéric Ogée and Olivier Meslay

When Walter Richard Sickert (1860–1942) exhibited his *Camden Town Murder* painting in 1911 in London (fig.6), he did so in the context of Roger Fry's recent introduction of 'modernism' to England in an exhibition of the works of the French Post-Impressionist painters, most prominently Cézanne, Gauguin and Van Gogh. Going against Fry's pronouncements in favour of a 'modern' art that extolled 'plastic design' and the aesthetic emotion of pure form, Sickert reminded his fellow citizens that modernity in English art had, from its origins, always been founded on narrative and a sensorial truth to nature. The *Camden Town Murder* painting was itself part of a series of drawings and oils that he had produced in the immediate aftermath of the actual crime and that combined to tell a story within a time-bound and quotidian framework. This was meant to appeal to the viewer's inner sense of the real and was true to an *English* tradition of 'modernity' that went back to one of the first prominent members of an English school of art, William Hogarth. Instead of abstraction, of formal idealism and of the elimination of the contingent, modernity in English art must, according to Sickert, stand against continental conceptual influences and rely on a dynamic, narrative conception of visual representation. Rooted in the particulars of shared experience, it was meant to draw its beholders into a world of poignant, tangible details that espoused the contours of their anxieties about modern life. Strikingly, it was exactly in the same, apparently insular terms that Hogarth positioned his own enterprise in the world of eighteenth-century London, both in relation to foreign 'high art' and in his adoption of a compositional grammar that expressed his conception of modern art.

English modernity

William Hogarth's arrival onto the London artistic scene took place at a time – the 1720s and 1730s – when modernity was understood and advertised as a synonym for Englishness or, since the 1707 Act of Union with Scotland, Britishness. To be modern meant to promote and represent the values – economic, political, religious, philosophical, artistic – in terms of which the new nation was determined to define itself, mostly in reaction against what was increasingly described as the 'yoke' of continental (read French) domination

Heads of Six of Hogarth's Servants c.1750–5 (no.116, detail)

FIGURE 6
Walter Sickert
(1860–1942)
The Camden Town Murder
c.1908–9
YALE CENTER FOR
BRITISH ART, PAUL
MELLON FUND

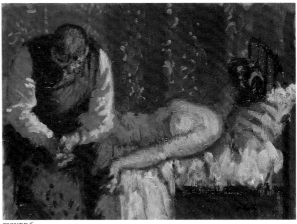

FIGURE 6

over the European scene.

With the legitimate pretender to the throne of England exiled across the Channel, the issue had a burning topicality. Declaring one's modernity became a political declaration of allegiance to the overall framework put into place since the Glorious Revolution of 1688, which had adroitly laundered the replacement of the pro-Catholic, pro-continental members of the Stuart dynasty with some of their more or less distant, pliable and largely disempowered Protestant relatives. By setting up the truly revolutionary principle of a political contract, to a large extent inspired by commercial thought, between the people and its rulers, which legitimised the replacement of the latter when they were deemed to have failed, the English shook one of the oldest pillars of European tradition – the divine right of kings – and thereby paved the way for the emergence of the two most important features of the nascent Enlightenment, and of our own modernity: public opinion and individual liberty.

Such a revolution, prepared by the Reformation's profound questioning of a closed, vertical and theological organisation of human affairs, was fuelled in England not only by the resistance to 'popish monarchy' and absolute tyranny but also by a new intellectual climate promoted by a generation of 'thinkers' – scientists, philosophers, preachers – who developed and broadcast a radically new comprehension of the world based on a free, personal and empirical apprehension of it. In effect, just as in religion, where a less mediated, more individual relationship to the deity was being sought, they encouraged a direct, consensual observation of God's creation rather than the contentious doctrinal debates about God Himself, which had led to so many bloody conflicts at home throughout the seventeenth century.

The foundation of 'The Royal Society for the Improving of Natural Knowledge' in London in the early 1660s – over which Isaac Newton was to preside at the turn of the century – fostered the emergence of a new scientific method that, instead of the verification of preconceived hypotheses, advocated an 'objective' observation of the 'particulars' of Nature and the writing of 'histories' of the causes and effects of natural phenomena, from which laws and theories could only subsequently be deduced. This new method was most famously illustrated by Newton's Law of Gravity and his *Opticks* (published in 1704). The philosopher John Locke, already behind the principles of the new political 'contract', formalised this approach in his *Essay Concerning Human Understanding* (1690–1700), in which he developed the principles of the new empirical epistemology, with great emphasis on the importance of a sensorial acquisition of knowledge.

Made possible largely thanks to the remarkable freedom of print after the lapse of the Licensing Act in 1695, the circulation of these new ideas quickly percolated through the various layers of society not only with the regular publication of the Royal Society's *Philosophical Transactions*, which recounted their experiments in all fields, but also in the new periodicals (*The Tatler, The Spectator, The Gentleman's Magazine*) that were widely circulated and eagerly read in clubs and coffee houses from the early decades of the eighteenth century. As could be expected, writers and artists were quick to discuss and represent the consequences of all those changes and of this new approach to nature – including human nature – and developed 'modern' forms of expression that could publicise and analyse them in a recognisably English, and free, idiom. Quite remarkably, these forms all appeared between the 1720s and 1740s.

In gardens, after trying to rival the French in Baroque grandeur (as at Castle Howard or Blenheim Palace), landscape designers (Charles Bridgeman, William Kent, Lancelot 'Capability' Brown) replaced the geometrical and architectural framing of nature with a more painterly and increasingly irregular, serpentine and 'natural' form of garden, which, while being in fact as sophisticated as its French counterpart, was presented as an emblem of English liberty and allowed the visitor a much more personal, sensory contact with God's creation. Soon known as 'the English landscape garden', it was often imitated throughout Europe, not least in France (*jardin anglais*), in the second half of the eighteenth century. Similarly, in literature there developed a genre of long prose narrative – later designated as 'the novel' – which problematised the causes and effects of an individual's integration within the new society. After Daniel Defoe's first attempts at 'realistic' stories (*Robinson Crusoe*, 1719, and *Moll Flanders*, 1722), Samuel Richardson, in his best-sellers *Pamela* (1740) and *Clarissa* (1748), developed the epistolary novel to examine the frictional energy released by the confrontation of several one-sided viewpoints, while Henry Fielding, with *Joseph Andrews* (1742) and *Tom Jones* (1749), explored what he called his 'new province of writing', offering panoramic, epic narratives of his heroes' progress through modern England. Finally, in art a new generation of painters and engravers laid the foundations of what was to emerge later in the century as the 'English school of art', by taking advantage of the new situation to redefine the traditional academic categories to their advantage and to steer portraiture – the quasi-exclusive genre in demand – towards modern 'realism'. Prominent among them was William Hogarth, whose initial handling of group portraiture known as 'conversation painting' developed into the representation of what he called 'modern moral subjects', based on a dynamic use of variety and narrative, two qualities that remarkably encapsulated the new priorities of the age and soon became, as Sickert was later to observe, the hallmarks of modernity in English art.

The freer expression of individual opinion, combined with a great increase in population and the disruption of social hierarchies by the dissemination of commercial prosperity, made diversity and variety conspicuous features in eighteenth-century society. This development was a source of wonder as much as of anxiety, and it fostered a great demand for guidelines and models of behaviour, which books of conduct,

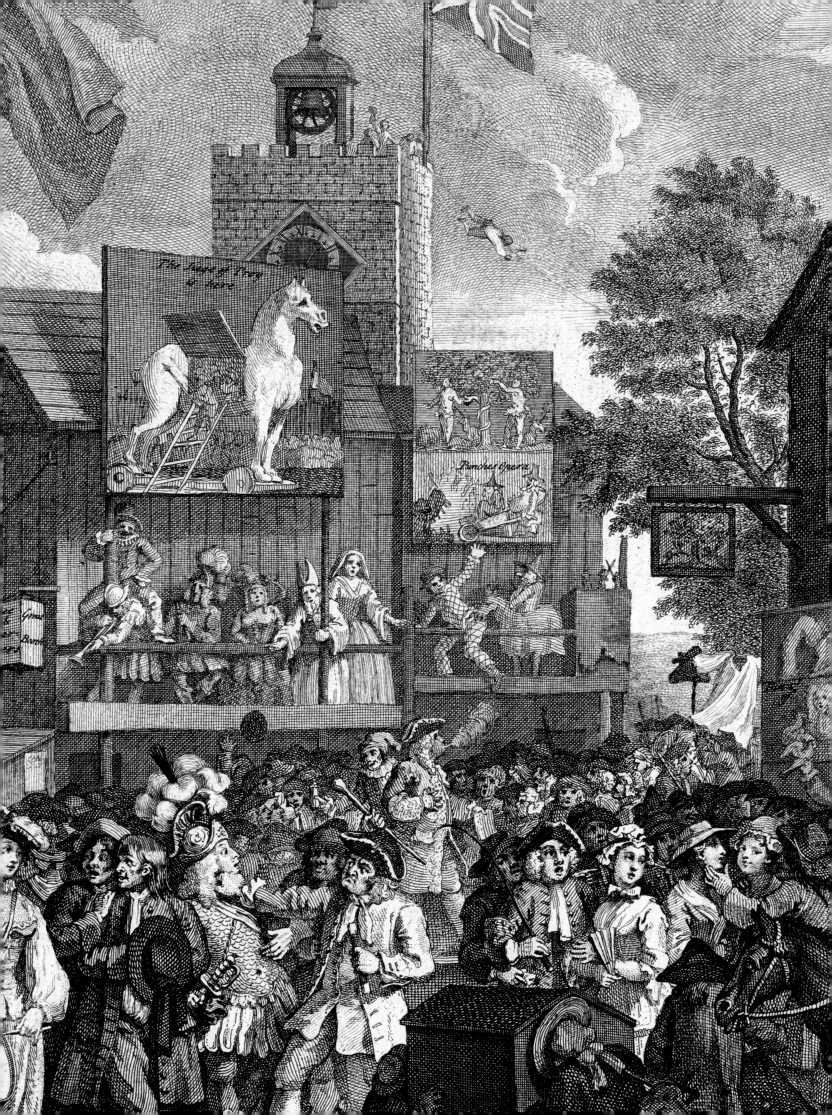

1
Introducing Hogarth: Past And Present

Christine Riding

In 1901 James McNeill Whistler (1834–1903) sent an angry note to the committee for the Fund for the Preservation of Hogarth's House. Enclosing a subscription to save the artist's villa in Chiswick (fig.5), Whistler wrote, 'I am told that nothing official has in the matter been done, either by the Government, or The Royal Academy, to keep in respect the memory of [the nation's] one "Master" who, outside of England, still is "Great".'[1] Why did the supreme artist of the Aesthetic Movement and champion of 'Art for Art's Sake' think so highly of William Hogarth?

In common with the majority of people in the nineteenth century, Whistler was introduced to Hogarth through engravings, having been given a book of Hogarth's prints as a child. But Whistler responded to Hogarth as both a printmaker *and* a painter whose brushwork and skilful use of colour he greatly admired. His interest in the painterly qualities of Hogarth's work was highly unusual in the Victorian period and remains so, even today. However, Whistler's appreciation of the artist as the great interpreter of modern urban life was more widely held. Indeed, Hogarth's ability to capture the throb of the city's streets and the diversity of its occupants within complex, multi-focal compositions was the starting point for a number of pictorial panoramas of nineteenth-century society, including David Wilkie's *Chelsea Pensioners Reading the Waterloo Dispatch* 1822, William Powell Frith's *Derby Day* 1858 and Ford Madox Brown's *Work* 1852–65. Whistler in his early career also focused on explicitly contemporary subjects, albeit in different mood to other Victorian artists. *Wapping* (fig.10) – a tavern scene on the Thames riverfront with a prostitute, her pimp and a sailor – exemplifies Whistler's detached,

unsentimental observations on the urban experience, paralleling Hogarth's own attitude towards the subject (see p.119–21). Whistler's later painting of a street hawker, *The Chelsea Girl* (Private Collection), executed in 1884, can be seen as homage to Hogarth's now celebrated *Shrimp Girl* (no.63), which had been acquired for the National Gallery in the same year.[2] For Whistler and others such street characters were central to Hogarth's powerful and enduring vision of London. In moving among the urban crowd, taking pleasure in the sights and sounds of the street, Hogarth was indeed the *flâneur* of his day.

Whistler's open-minded appreciation of Hogarth allowed him to position the artist's work within a canon of seventeenth- and eighteenth-century European painters; he was described as 'never tiring in his praise of the luminosity of Claude, the certainty of Canaletto, the wonderful tones of Guardi, the character and colour of Hogarth'.[3] To commentators in the decades after Hogarth's death, however, his genius was primarily that of the satirist. In his *Anecdotes on Painting in England* (1780) the aristocrat and art-connoisseur, Horace Walpole, celebrated Hogarth's pre-eminence as a satirical printmaker. Significantly, Walpole located Hogarth's work within the world of literature and drama, rather than of art, describing him as 'a writer of comedy with a pencil' in the spirit of Molière and William Congreve.[4] This comment in some measure echoes Hogarth's own description of his work in theatrical terms. But Hogarth also took great pains to promote himself as an original thinker and as an artist of substance within a range of genres. This is powerfully demonstrated by his self-portraits included in this section, which as

The Shrimp Girl c.1740–5
(no.63, detail)

FIGURE 10
James McNeill Whistler
(1834–1903)
Wapping 1860–4
NATIONAL GALLERY
OF ART, WASHINGTON

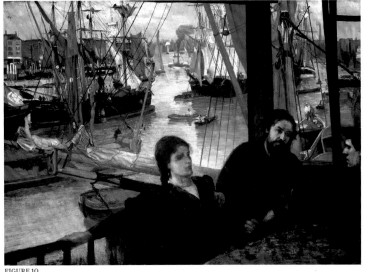

FIGURE 10

a group represent a sophisticated and wide-ranging artistic manifesto (see nos.1, 4, 8). However, both Walpole and Sir Joshua Reynolds, the first president of the Royal Academy, sought to edit and fix Hogarth's legacy, dismissing outright his contribution to British history painting. Indeed, Reynolds noted in his fourteenth *Discourse* (1788) that, while Hogarth should be celebrated for inventing 'a species of dramatick painting' and for his ability 'to explain and illustrate the domestick and familiar scenes of common life', his ambitions in 'the great historical style' were not only imprudent but presumptuous.[5]

Such partial evaluations and outright condescension towards Hogarth were to be expected in the British art world of the second half of the eighteenth century, given the theoretical dominance of Reynolds's Grand Manner style with its seductive, idealising tendencies, and the creation in 1768 of a hierarchical, continental-style Academy, against which the work of all native artists, dead or alive, was now measured. Hogarth's aversion to flattery, his penchant for satirical irony and his unflinching observations of urban life did not chime with an age that also spawned the 'cult of sensibility' and a vogue in British society portraiture for sitters cast as 'men and women of feeling', paralleled by sentimentalised representations of prettified poverty and rustic idylls. Reynolds was not alone in grouping Hogarth with seventeenth-century Dutch and Flemish genre artists, 'who', as Reynolds stated, 'have applied themselves more particularly to low and vulgar characters'.[6] That Hogarth's modern moral subjects and political series were also too forceful and unmitigated for a certain kind of eighteenth-century French spectator is suggested by a French connoisseur's comments on seeing the paintings of the *Election* series (nos.120–3) at David Garrick's house in 1765. 'These pictures', he noted, 'are in the taste of old Breughal ... It is pure nature but nature too naked and too true; a truth very different from that displayed by two of the masters of the present French school, Messieurs Chardin and Greuze.'[7] Nevertheless, Jean-Baptiste Greuze showed more than a passing interest in Hogarth's work during the 1760s. His *Le malheur imprévu* (before 1763), for example, was influenced by the *Before* and *After* prints of 1736 (no.42, see also p.29). But such moral genre subjects by Greuze were invariably imbued with modish *sensibilité* and thus lacked Hogarth's characteristic sting.

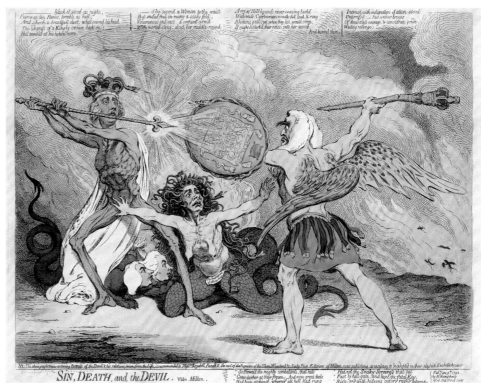

FIGURE 11

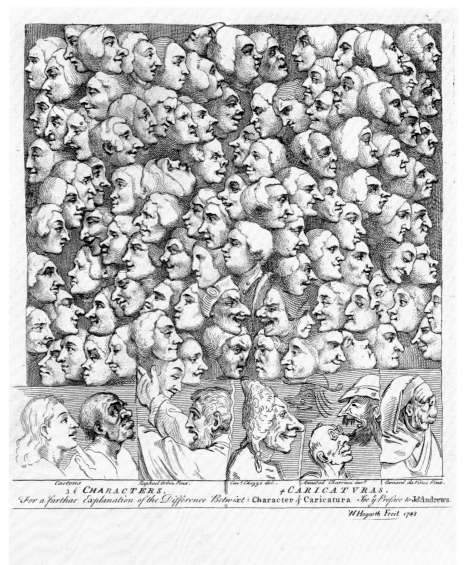

FIGURE 12

Perhaps not surprisingly, it was in graphic satire that Hogarth's influence was most obviously seen in late eighteenth-century Britain. Indeed, his highly successful modern moral subjects and other satires had given this genre a new artistic and commercial credibility (tellingly, satirical prints were excluded from the Royal Academy). Hogarth's 'successors', in particular James Gillray (1757–1815), acknowledged their enormous debt to him by continually alluding to or borrowing from his compositions, even those that were not intended to be satirical. To give a famous example, Hogarth's *Satan, Sin and Death* (no.103), inspired by Milton's *Paradise Lost*, was deftly reworked by Gillray in 1792 (fig.11) as a political satire concerning the power struggle between the Prime Minister William Pitt and the Chancellor Edward Thurlow, with Queen Charlotte intervening.[8] While referencing the work of other artists was a staple of such prints, it is worth noting that the 'golden age' of British graphic satire (from the 1780s to the 1820s) was concurrent with a boom in the art market for Hogarth's prints, largely for use as private entertainment, a phenomenon described by the scholar Edmund Malone in 1781 as 'Hogarthomania'.[9]

One aspect of Gillray's approach was, however, distinctly un-Hogarthian, namely his use of caricature. In *Characters and Caricaturas* (fig.12) Hogarth sought to disassociate his work from caricature, visually setting out its boundaries and limitations and underlining that the depiction of character made far greater intellectual and artistic demands than distorting facial features merely for the purposes of ridicule. The same argument was made in the preface to Henry Fielding's *Joseph Andrews* (1742), no doubt in collusion with Hogarth, who was a close friend. Hogarth, it was stated, was not a 'Burlesque painter' but a 'Comic History Painter', who seeks to 'express the Affections of Men on Canvas'. Thus, according to Fielding, Hogarth's figures – resulting from the close observation of Nature – not only 'seem to breathe' but 'appear to think'.[10]

Hogarth's critical fortunes changed dramatically during the nineteenth century. During this time his reputation as the bluff, plain-speaking, patriotic Englishman, whose art was based on instinct and observation rather than learning, was all but set in stone.[11] This reassessment – in many ways as flawed and partial as Walpole's and Reynolds's previously described – developed during an extended period of national crisis and international conflict, the French Revolutionary and Napoleonic Wars (1792–1815), which was more intense even than that experienced during Hogarth's own lifetime. The result was a strong impulse to celebrate past 'British Masters': both Reynolds and Hogarth were, for example, the subjects of public exhibitions at the British Institution in 1813 and 1814 respectively. Another was to locate qualities that distinguished the

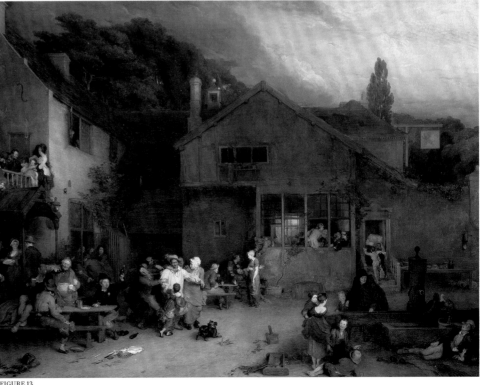

FIGURE 13

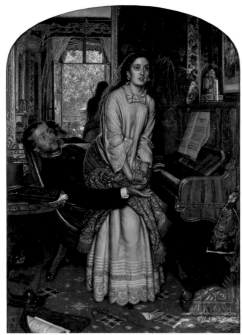

FIGURE 14

British school of art from its French counterpart. One source of national pride was that the classical tradition and academic hierarchy of genres had not taken hold in Britain as it had across the Channel, demonstrated by the thriving school of contemporary-life painters led by David Wilkie (1785–1841). Wilkie was the most innovative genre painter of his generation, who achieved international renown and was admired by such luminaries of French Romanticism as Théodore Géricault and Eugène Delacroix, particularly for his acute and varied characterisations.[12] Nineteenth-century commentators admired the exact same qualities in Hogarth.[13] Unsurprisingly Wilkie was perceived as the Hogarth of his day (despite the fact that his work fused humour and social criticism with Romantic sensibility and pathos). *The Village Holiday* (fig.13), which represents the kind of narrative/moral genre painting that established his reputation, takes the topical subject of drunkenness in society as its theme and the outskirts of London as its setting. The inn itself is based on one situated in Paddington. Wilkie had been inspired by a scene of drunkenness that he had witnessed as he wandered round the city's streets. In this sense *The Village Holiday* exemplifies Hogarth's own emphasis on personal observation and experience as the cornerstone of the artist's practice (see nos.5–6).

Wilkie, more than any other artist, established the fashion in Britain for genre painting during the nineteenth century,

especially narrative genre. But it is possible that he also provided a contemporary context for Hogarth through works such as *The Chelsea Pensioners* and *The Village Holiday*, and thus an opening for a wider audience to appreciate Hogarth's work per se. *The Village Holiday* was, for example, in the collection of John Julius Angerstein, who also owned Hogarth's *Marriage A-la-Mode*. Both were transferred to the National Gallery in 1824 and quickly became the favourite paintings of the British public.[14] This also serves to remind us of the importance of public exhibitions in establishing reputations and stimulating artistic responses, in addition to the ongoing impact of engravings and the print market. For example, the architect John Soane acquired *A Rake's Progress* (no.44) in 1802 and the *Election* series (nos.120–3) in 1823. Both were assigned to his purpose-built museum in 1833 and made accessible to students, artists and members of the public.[15] These permanent displays were supplemented by temporary exhibitions, such as the massive Manchester Art Treasures exhibition in 1857, which included *Southwark Fair* (no.65), *March to Finchley* (no.113), *The Beggar's Opera* (nos.38–9), *David Garrick as Richard III* (no.105) and numerous other works by Hogarth.

It is surely no coincidence that the notable increase in artistic responses and Hogarthian echoes executed in the middle decades of the nineteenth century, and beyond, occurred at the moment when

FIGURE 14
William Holman Hunt
(1827–1910)
The Awakening Conscience
1853
TATE. PRESENTED BY
SIR COLIN AND LADY
ANDERSON THROUGH THE
FRIENDS OF THE TATE
GALLERY 1976

FIGURE 15
Edward Matthew Ward
(1816–1870)
Hogarth's Studio in 1739
1863
YORK CITY MUSEUMS
TRUST (YORK ART
GALLERY)

FIGURE 16
Steve Bell (born 1951)
*Free the Spirit, Fund the
Party* 1995
COURTESY STEVE BELL

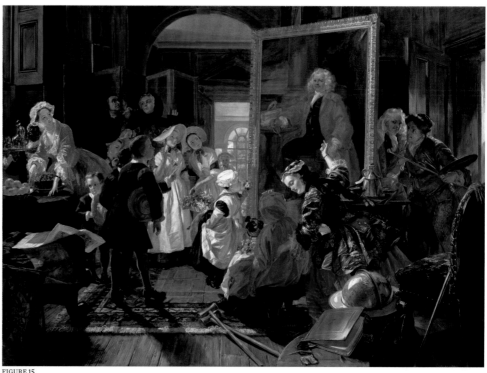

FIGURE 15

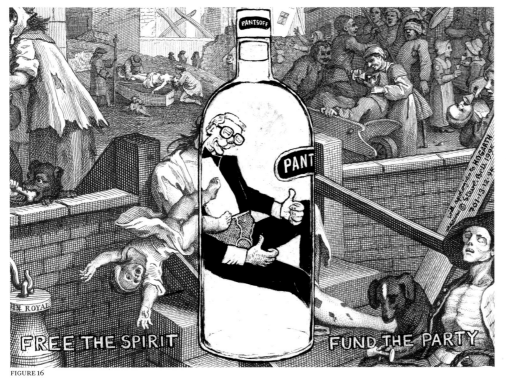

FIGURE 16

many more examples of Hogarth's painted works were introduced into the public domain. Benjamin Robert Haydon's *The Mock Election* (1827) and *Chairing the Member* (1828) brought scenes from the *Election* series up to date with topical resonances. Similarly William Powell Frith painted a contemporary series entitled *The Road to Ruin* (1877), which he described as 'a kind of gambler's progress, avoiding the satirical vein of Hogarth'.[16] John Everett Millais explored different aspects of contemporary marriage in a series of drawings entitled *Married for Rank*, *Married for Money* and *Married for Love* (1853).[17] Augustus Egg based his trilogy, *Past and Present* (1858), on a Hogarthian format of 'cause and effect', taking as its subject the discovery of a wife's adultery and its consequences to the family. Similarly William Holman Hunt's *The Awakening Conscience* (1853–4) engages with the contemporary subject of the 'fallen woman', showing a kept mistress with her wealthy lover (fig.14). The scene is set in the parlour of a 'maison de convenance' in north London, the gaudy extravagance of which rivals the Squanderfields in *Marriage A-la-Mode*, as does the plethora of symbolic detailing. And so it goes on. Perhaps not surprisingly, Hogarth became the subject of a number of historical genre paintings during this time. Frith, for example, provided a sequel to Hogarth's *O The Roast Beef of Old England* (no.112) entitled *Hogarth before the Commandant at Calais* (1851). And in 1863 Edward Matthew Ward exhibited *Hogarth's Studio in 1739* (fig.15), with Hogarth

and Thomas Coram hiding behind Hogarth's portrait of Coram on the right, listening to the admiring chatter of visitors and children from the Foundling Hospital, as Mrs Hogarth cuts a cake on the left.

These examples, to a greater or lesser extent, underline the enthusiasm for, and wide-ranging practice in, narrative genre paintings, as well as a 'Hogarthian' engagement with modern urban life, described at the beginning of this essay. But a number also reflect the then prevailing ethos of 'art as moral teacher'. Their association with Hogarth thus highlights another aspect of his life and work that was appropriated and exaggerated by commentators and subsequently entered the popular consciousness, namely Hogarth's identity as the great moral painter of his time. That his cautionary tales were perceived as relevant to a contemporary audience is also underlined by the numerous pamphlets that appeared, such as Reverend T.B. Murray's verse narrative *The Two City Apprentices; or, Industry and Idleness Exemplified; a London History* (1846). Over and above the evidence of his work, Hogarth himself was seen to personify the kind of industriousness, drive for self-improvement and aversion to all manner of voguish 'humbug' that chimed with middle-class attitudes to work and society in general. And his position as a highly suitable role model was heightened by his reputation as a philanthropist and champion of the underdog, as evoked in Ward's fanciful painting.

The modern and contemporary responses to Hogarth by David Hockney, Paula Rego and Yinka Shonibare included in this section underline how adaptable his output continues to be in the present (see nos.9–13). Moreover, Hogarth remains a rich source for graphic satirists, as demonstrated by Steve Bell's use of *Gin Lane* (no.98) in his political cartoon *Free the Spirit, Fund the Party* (1995; fig.16), which deftly conflates Hogarth's celebrated image of a gin-soaked society, the advertising campaign of the 1990s for Smirnoff vodka and Bell's ongoing representation of Prime Minister John Major as a dull version of Superman. But while Hogarth can be recognised as a satirist, a patriot and a political and social commentator – to name but a few of his identities that have been absorbed and discussed up to the present – what of Hogarth the painter? No one who has seen his portrait of *Mrs Salter* (no.89), *The Shrimp Girl* (no.63) and a gamut of other works could possibly doubt that Hogarth was deeply concerned with both composition and surface values, including the application and texture of paint and the nuances of colour. Perhaps the layers of symbolic meaning and narrative that are so crucial to Hogarth's art still distract us from his astonishing abilities with the brush. Others have been more attentive. In the 1880s Whistler's friend and pupil, Harper Pennington described a trip to the National Gallery, where he was immediately drawn to *Marriage A-la-Mode*:

Upon that day, I had supposed that what I was told, and had read, of Hogarth was the truth – the silly rubbish about his being *only* a caricaturist and so forth and so on; so that when I was confronted with those marvels of technical quality, I fairly gasped for breath.

He rushed over to Whistler and exclaimed:

'Why! – Hogarth! – He was a great Painter!' to which Whistler replied, 'Sh-sh!' ... (pretending he was afraid that some one would overhear us). 'Sh-sh-yes! – I know it! ... But don't you tell 'em!'[18]

1

Self-Portrait with Palette c.1735
Oil on canvas
54.6 × 50.8
YALE CENTER FOR BRITISH ART.
PAUL MELLON COLLECTION

Hogarth seems not to have been a prolific self-portraitist, with only three oil portraits having survived into the present. These remained in the artist's possession and were most likely displayed in his studio. *The Painter and his Pug* 1745 (no.4) and *Hogarth Painting the Comic Muse* c.1757 (no.8) are two of Hogarth's most famous images. Painted neither for pleasure nor for private consumption, they were carefully and deliberately conceived as public statements of artistic achievement, ambition and status. They were thus always intended to be engraved and widely circulated.

This lively, unfinished painting is generally held to be Hogarth's first self-portrait. If the approximate date is correct, he would have been in his mid- to late thirties. As with the other self-portraits, it can be viewed as a self-advertisement. By 1735 Hogarth had achieved fame as an innovative pictorial satirist and carved a niche for himself as a painter, primarily of conversation pieces (see p.95). In the mid-1730s Hogarth took on new and ambitious projects, which were more emphatic declarations of 'the gentleman artist'. His professional and social aspirations were signalled by his move to a residence in the highly respectable Leicester Fields in 1732; above the front door he placed a bust of Van Dyck, the seventeenth-century court painter. After this came his leadership of the St Martin's Lane Academy, re-formed in 1735, and his first attempt at grand history painting at St Bartholomew's Hospital (1734–7). Despite these artistic developments, for most of the 1730s Hogarth was primarily known for his satirical prints. The fact that he wanted to assert his identity as a painter may explain the absence of references to engraving in the self-portrait and the presence of the artist's palette, which, given its cramped position in the lower corner, was perhaps a later addition.

In general terms, the composition presents Hogarth first and foremost as a gentleman, demonstrated by the 'public' costume of a powdered wig, frock coat, white shirt and cravat, accompanied by a pleasing ease of manner and distinct lack of ostentation. A similar tone was employed by the most successful portrait painter in early eighteenth-century London, Godfrey

Kneller, in his ensemble of forty-four Kit-Cat Club portraits c.1703–17 (fig.17). Hogarth owned an engraved set of these portraits.[19] Kneller's approach was to simplify the dress, minimising the details of fashion (as well as professional 'attributes'), thus drawing attention to the personalities and decorous poses assumed by the sitters. In the context of early eighteenth-century portraiture the Kit-Cat series are characterised by their gentlemanly informality. Some of the sitters wear shirts opened at the neck, and most are in plain brown or occasionally blue velvet coats (a small group are wearing loose gowns). The vast majority wear periwigs, a standard accoutrement of 'the gentleman' at this time, with a few sporting soft caps (see p.40). What would have made this corporate image of understated gentility and conviviality particularly appealing to an ambitious man like Hogarth is that the sitters include a range of professional men, i.e. publishers, playwrights, essayists and scientists, such as Isaac Newton, Richard Steele, Jacob Tonson (see no.4) and Joseph Addison, who are presented on an equal footing with the aristocratic members of the club. That this kind of representation had become de rigueur for 'gentleman artists' by the 1730s is underlined by Gawen Hamilton's *A Conversation of Virtuosis* 1735 (National Portrait Gallery, London), showing members of a club of artists, including the engraver and antiquary George Vertue (p.40), the engraver Bernard Baron (p.46) and the designer and painter William Kent (p.59).

Importantly, the famous dining club The Sublime Society of Beefsteaks was also formed in 1735, headed by Hogarth and the theatre impresario, John Rich. Thus Hogarth's strategy in his first self-portrait was clearly to present himself as a 'clubbable' gentleman, allowing his ability as an artist to speak largely for itself through the assured, energetic brushwork, the subtle use of colour and tone, and the natural and expressive qualities of his face.

FIGURE 17
Godfrey Kneller
(1646–1723)
Joseph Addison 1703–17
NATIONAL PORTRAIT
GALLERY, LONDON

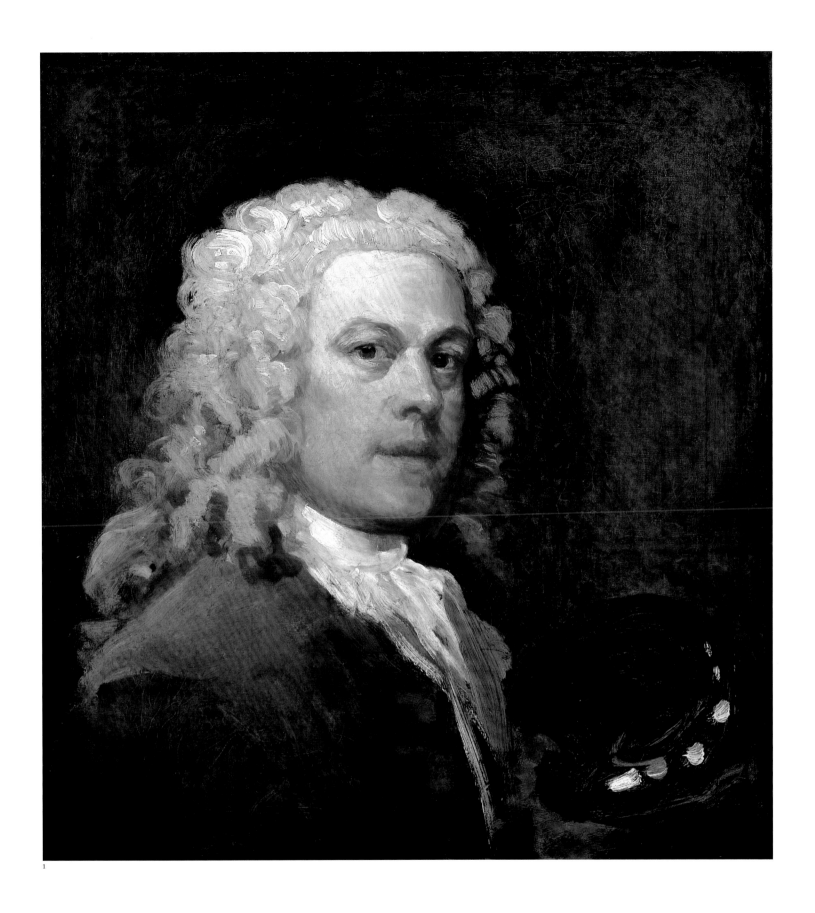

2

Louis-François Roubiliac (c.1702–1762)
William Hogarth c.1741
Terracotta
71.1 high
NATIONAL PORTRAIT GALLERY, LONDON

Roubiliac was one of the foremost foreign artists working in London during Hogarth's lifetime and the leading exponent of a highly expressive and animated style of sculpture, which was thus the antithesis of 'classical' restraint. He was born in Lyons in about 1702. As part of his early training, he may have travelled to Dresden and Rome before entering the Académie Royale in Paris in the late 1720s. After arriving in London in 1730, he promptly associated himself with the Freemasons and the Huguenot community and became a prominent figure in Hogarth's cosmopolitan circle and habitué of Old Slaughter's coffee house. These interrelated

groups and venues provided him with valuable contacts and/or commissions. Roubiliac was also a member of the St Martin's Lane Academy and taught sculpture there in the 1740s.

It was probably via his association with Hogarth and the other Academy members that Roubiliac was commissioned by Jonathan Tyers, owner of the fashionable Vauxhall Gardens, for the statue of the celebrated composer George Frideric Handel. Hogarth was a friend of Tyers and encouraged him to display art at Vauxhall, thus giving Academy artists, such as Roubiliac and Francis Hayman, greater public visibility (the decorations included, for example, authorised copies of two scenes from Hogarth's *The Four Times of Day* series). Roubiliac's statue of Handel was installed in April 1738 and caused an immediate sensation. The life-size figure

was characterised by its expressiveness and informality of dress and pose (conventionally used for bust portraits), which struck commentators as intimate, characterful and dignified. This approach proved highly influential for subsequent portraits by Academy painters, in particular those by Hayman, and may have acted as a cue to Hogarth, especially in his full-length portrait of Thomas Coram (no.84).

Roubiliac was renowned both for his extraordinary technical facility and for capturing a likeness. In 1741 George Vertue noted that the sculptor had modelled 'several Busts or portraits' of the poet Alexander Pope, the architect Isaac Ware, Hogarth and others, which were 'very like' and 'exact Imitations of Nature.'[20] It is generally held that no.2 is the portrait of Hogarth mentioned by Vertue, which remained in Hogarth's possession until his death. He is shown wearing a gown with braid fastenings, a shirt opened at the neck, and a soft cap. The sheer volume of eighteenth-century portraits showing a male sitter in similarly informal, gentlemanly 'undress' underlines the vogue for what Joseph Addison described in 1711 as 'agreeable Negligence'.[21] In the early decades of the century, however, this style of representation in portraiture was associated with virtuosi, artists and the like, who were sometimes shown holding attributes of their professions or intellectual pursuits, or momentarily pausing while reading or composing. The format was more widely adopted during the 1740s.

What Roubiliac brought to this convention, particularly evident in the bust of his friend Hogarth, was an uncanny sense of a momentary state, frozen in time. The turn of his head, the parted lips and attention to the details of the face, which include a long scar above the right eye, makes tangible Hogarth's strength of character, individuality and dynamism, just as the cap pulled jauntily over one ear to reveal the short-cropped hair and the slightly dishevelled shirt lends the portrait both movement and a raffish air, which Hogarth would have undoubtedly enjoyed.

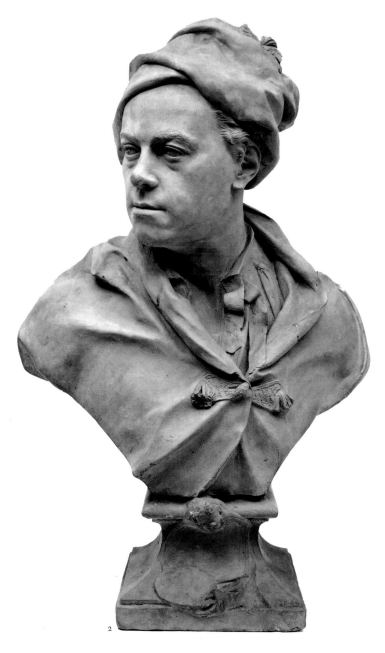

2

3

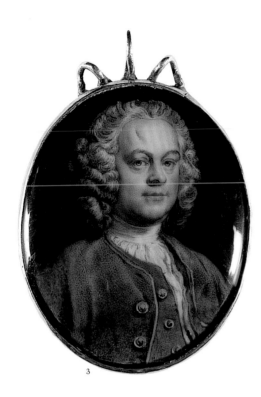

3

Attributed to Jean André Rouquet
(1701–1759)
William Hogarth c.1740–5
Enamel on copper
4.5 × 3.7
NATIONAL PORTRAIT GALLERY, LONDON

Rouquet, a member of the Académie Royale in Paris, was born in Geneva into a family of refugee French Protestants. He came to London in about 1722 and worked as a painter of portrait miniatures in enamel for the next thirty years. Like Roubiliac, he was a long-standing friend and associate of Hogarth. Today he is primarily remembered as the author of *The Present State of the Arts in England* (*L'État des Arts en Angleterre*) published in Paris and London in 1755, which, as R.W. Lightbourn has noted, was the only contemporary survey of English art published between 1730 and 1755.[22] Importantly, Rouquet also authored two accounts of Hogarth's works in French, with the intention of promoting sales and greater appreciation of the artist on the continent. The first, published in 1746, was *Lettres de Monsieur [Rouquet] à un de ses Amis à Paris, pour lui expliquer les Estampes de Monsieur Hogarth*, which included commentaries on the engraved versions of *A Harlot's Progress*, *A Rake's Progress* and *Marriage A-la-Mode*.[23] The second, *Description du Tableau de Mr. Hogarth, qui Represente La Marche des Gardes à leur rendez-vous De-Finchley, Dans leur Route en Ecosse*, was published between 1749 and 1750, at which point all four commentaries were printed in the same pamphlet. Hogarth included copies of Rouquet's commentaries when despatching sets of his prints abroad.[24]

The present portrait miniature, attributed to Rouquet, is of interest primarily because of its relationship with the development of Hogarth's *The Painter and his Pug* (no.4). Hogarth is shown wearing a similar costume to that worn in no.1. Interestingly, there is no artist's palette or any other indication of his profession. It thus follows the same formula of plain, unaffected gentility employed, for example, in Hogarth's portrait of George Arnold (no.86). By 1745, however, this kind of representation (and in particular the style of wig) would be deemed conservative and thus sartorially unremarkable. Indeed, Aileen Ribeiro has recently noted that the powdered wig, through its wholesale deployment among the middle and upper classes, was thought in some quarters to undermine individuality and character and

was, by its very nature, 'unnatural'.[25] Importantly, no.3 closely follows Hogarth's original composition for *The Painter and his Pug* (no.4). Given that the latter portrait is, in its finished state, a carefully constructed manifesto of Hogarth's artistic beliefs, with an emphasis on innovation, individuality and 'Nature', it is not surprising that he decided to rework dramatically the composition of no.4. In this context, it is important to note that Hogarth was at this time formulating his ideas on beauty and aesthetics that eventually materialised as a treatise entitled *The Analysis of Beauty* (no.5).

4

The Painter and his Pug 1745
Oil on canvas
90 × 69.9
TATE. PURCHASED 1824

This commanding self-portrait is one of
Hogarth's best-known works. In general
terms, the oval, half-length or bust portrait
(normally set within an architectural
composition) follows a well-established
formula for portrait engravings of poets and
writers that were used as frontispieces in
books. Indeed, Hogarth engraved this work
in 1749 as the frontispiece for published
folios of his own prints (see p.236). In its
original conception (revealed through
X-rays of the canvas) Hogarth pictured
himself as a public figure in a shoulder-
length wig and plain clothes, similar to that
exhibited in the miniature portrait shown
above (see no.3). This conventional,
gentlemanly representation was
superseded during the early 1740s by the
present image, which emphasises the

intellectual and artistic. Perhaps not
surprisingly, given his burgeoning
ambitions as an art theorist at this time,
Hogarth had chosen to depict himself in 'the
practical attire [associated with] the man of
letters at work, at home or in the company
of intimates'.[26] In addition, the clothes are
arranged in such a manner as to appear
more generalised or timeless, thus imbuing
the sitter with dignity and authority. The
line of the red silk morning gown, gathered
in folds across Hogarth's chest, is echoed by
the green draperies flanking the oval
canvas. The fur-trimmed cap with gold-
thread tassel replaces the soft cap, which
was more frequently seen in portraits of
gentlemen dressed *en déshabillé* (as seen in
nos.2 and 8) and thus may have been
intended by Hogarth as an 'exotic' or quirky
flourish.[27]

While the oval format was common in
engraved and painted portraiture, the oval
self-portrait as part of a still-life
composition (although used in engravings)

was more ambitious and unusual in painted
form. A seventeenth-century precedent
was that executed by the Spanish artist,
Bartolomé Esteban Murillo (fig.18). Hogarth
may have known the portrait, as it was
imported to England in the early eighteenth
century. It shows the artist bare-headed and
sombrely dressed, looking out towards the
viewer, his hand resting on the oval frame.
Murillo painted the portrait for his children
as a testament to his artistic achievements
and status. The composition thus includes
the instruments of his profession, a palette,
brushes, pencils and a drawing. Similarly,
Hogarth includes brushes and a palette in
the foreground. In the print version he
added an engraver's burin (see no.128).

The foreground of no.4 is dominated by
the presence of the dog, which is generally
accepted as a portrait of Trump, Hogarth's
pug. On one level, this is a humorous, highly
personal element of the composition, as
Hogarth is said to have often remarked on
the physical resemblance between himself

FIGURE 18
Bartolomé Esteban
Murillo (1617/18–1682)
Self-Portrait 1670–3
THE NATIONAL GALLERY,
LONDON

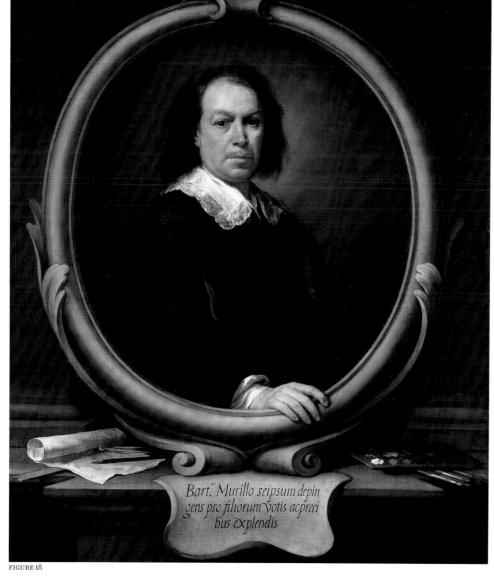

*Bart.ᵉ Murillo seipsum depin
gens pro filiorum votis acpreci
bus explendis*

FIGURE 18

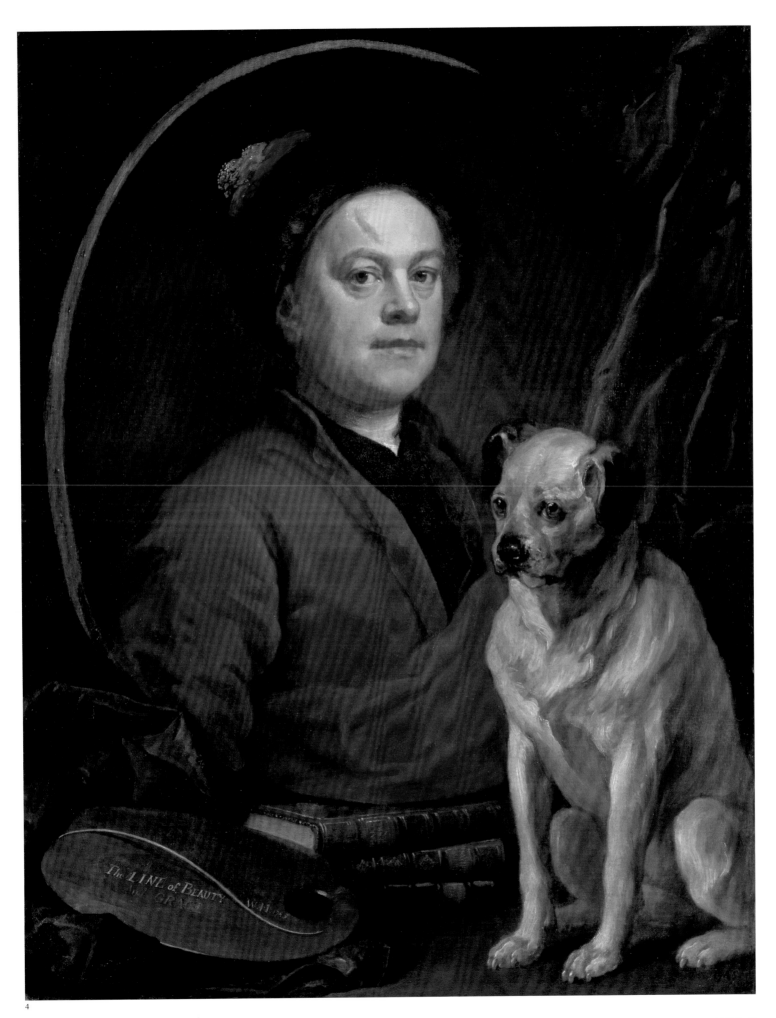

and his pet. And it may also represent a pun on the word 'pugnacious', which was one of Hogarth's defining characteristics. In an artistic context, however, the pug may represent 'Nature', the observation of which was key to Hogarth's approach to art and his treatise *The Analysis of Beauty* (no.5). As if to underline the point, Hogarth proudly sports his long scar above his right eye, rather than edit it out as an 'imperfection'.

Thus, while Murillo concentrated on his identity as an urbane and skilful artist, Hogarth's portrait is clearly a more layered and emphatic statement. This is underlined by the inclusion of the three volumes on which his portrait rests. These read 'SHAKE/SPEARE', 'SWIFT/WORKS' and 'MIL[TON]/P[ARADISE]/LOST' respectively on their spines. Hogarth states that his art draws inspiration from, and parallels with, English drama, satire and epic poetry, thus establishing a broader cultural context and national agenda within the self-portrait. In addition, the books may signal Hogarth's ambitions as an author. By 1745 William Shakespeare (1564–1616) was widely perceived as a national hero and representative of a particular brand of English genius. Hogarth created a number of Shakespearean works, including the spectacular *David Garrick as Richard III* (no.105) completed in the same year as the present self-portrait. Importantly for Hogarth, Shakespeare was lauded above all for the power and scope of his characterisations. And his plays embraced a range of theatrical and literary genres, from history and tragedy to comedy and romantic tragic-comedy. In Hogarth's self-portrait, therefore, Shakespeare not only represents the very best of English drama but also 'variety', a key concept in Hogarth's theoretical ideas on beauty in art and nature. Indeed, Hogarth quoted Shakespeare in *The Analysis of Beauty*. Focusing on a phrase gleaned from *Antony and Cleopatra*, Hogarth noted: 'Shakespear[e], who had the deepest penetration into nature, has sum'd up all the charms of beauty in two words, INFINITE VARIETY.'[28]

Like Shakespeare, John Milton (1608–74) was perceived as a cornerstone of the English literary tradition. He wrote *Paradise Lost* (1667/1674) at a time when epic poetry was thought to be a dying art. Importantly, it is a biblical epic composed in the English language, which adapts the conventions of revered classical literature, such as Virgil's *Aeneid* and Homer's *Iliad* and *Odyssey*. Milton's work was soon acknowledged to be

a masterpiece. Indeed, the poet and playwright John Dryden (1631–1700), whose own ambitions in epic poetry came to nothing, described it as 'one of the greatest, most noble, and most sublime POEMS, which either this Age or Nation has produc'd', a sentiment echoed by numerous seventeenth- and eighteenth-century British and continental commentators including Voltaire.[29] The high status of the poem and its author was signalled by the publication from 1688 of deluxe, illustrated editions by Jacob Tonson (see no.38). Hogarth's responses to *Paradise Lost* included *Satan, Sin and Death* (1735–40), one of his earliest history paintings (see no.103), and a quotation from *Paradise Lost* featured prominently on the title page of *The Analysis of Beauty* (fig.1).

While Shakespeare and Milton were in many ways obvious choices for Hogarth, the reference to his contemporary Jonathan Swift (1667–1745) is more intriguing. During his long and controversial career Swift, an Anglo-Irishman, was a poet, historian, journalist, political writer and Anglican priest. Most importantly to Hogarth, he was also the outstanding prose satirist of his day. Among his numerous published works were *A Tale of a Tub* (1699/1704), a satire on religious practice and contemporary 'hack' writing (see p.137), and *Travels into Several Remote Nations of the World* (1726), a satire on human pride and pretence in the context of contemporary politics and society. Now familiarly known as *Gulliver's Travels*, it was a huge, if controversial, success and much commented on in Britain and on the continent. Hogarth executed a print within months of its publication, in December 1726 (no.26).

By making reference to Swift, Hogarth was inviting his audience to draw parallels between them as satirists. In 1728 Swift wrote in *The Intelligencer* that 'There are two Ends that Men propose in writing Satyr', which were 'private Satisfaction' and 'a *publick Spirit*, prompting Men of *Genius* and Virtue, to mend the World as far as they are able'.[30] While Swift and Hogarth clearly had personal agendas and played to the crowd in the name of entertainment, they both sought to encourage critical thinking, in the understanding (to quote Michael Suarez on Swift) 'that satire, for all its comic laughter, must lead us to the painful knowledge of the world's falsity and of our own shortcomings'.[31] Despite this highly moral subtext, Swift's work was misunderstood by some as misanthropic and gratuitously vulgar. His mental state was also queried,

especially at the time of his death in 1745.[32] Of course, Hogarth's career was not without its controversies, which might be described as an occupational hazard of a satirist. And that he was sensitive to criticism of being a 'Burlesque' or vulgar painter at the time of the present self-portrait is underlined by Henry Fielding's comments in the preface to *Joseph Andrews* (1742) quoted above (see p.33). But Hogarth, as we know, also revelled in the provocative. That he was preparing to be just that within the contentious and rarefied world of art theory is underlined by the 'Line of Beauty' tantalisingly displayed on his palette.

10

David Hockney
*Programme cover for the Glyndebourne
Festival Opera production of* The Rake's
Progress 1975
Offset lithography on paper
30 × 25
TATE LIBRARY AND ARCHIVE

11

David Hockney
*Poster for the San Francisco Opera production
of 'The Rake's Progress'* 1982 featuring
Hockney's design for the 'Bedlam' scene
Ink on paper
99.1 × 86.4
PRIVATE COLLECTION

10

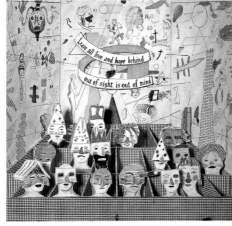

11

In the summer of 1974 David Hockney was asked to produce designs for the forthcoming Glyndebourne Festival Opera production of *The Rake's Progress*. Stravinsky had used Hogarth's original tale for his opera, completed in 1951, with a libretto written by W.H. Auden and Chester Kallman. The invitation came at an opportune time for the artist as he was looking for alternatives to the compulsive pursuit of academic drawing that had overcome him, and this project provided the vehicle for his release into a more adventurous style. In an attempt to convey his ideas as comprehensively as possible, Hockney not only produced drawings but also made scale models of the sets.

Hockney studied both the libretto and Hogarth's original series of paintings and prints in great depth for inspiration. He also looked beyond this individual series to Hogarth's work as a whole. Indeed, Hogarth's method of design for the prints accompanying *The Analysis of Beauty* (no.6, fig.1) – having a central tableau with boxes containing studies around the edge – had a great bearing on Hockney's initial design for the drop curtain of the production (fig.20). Small details of the musical score, colours and etching technique are contained in boxes beneath the introductory design. Hockney also made a feature of these

studies for the cover of the programme accompanying the production (no.10) and in the final scene of the opera showing the rake in Bedlam, although here the elements are released in anarchic disarray from their containment. The characters in Hockney's *Bedlam* scene refer back to Hogarth's original, such as the figure wearing a pointed hat with crosses on it and the musician with a musical score on his head. For the decoration of the interiors Hockney turned to elements of Hogarth's early series *Hudibras* (nos.28–34), most notably the bizarre stuffed crocodile hanging from the ceiling, taken from *Hudibras and Sidrophel* (1725/6).

Hockney took inspiration from Hogarth's original prints, not only their composition, design and aesthetic but also their technique. Crosshatching, a method so prominently used by Hogarth in his graphic work, was also employed by Hockney in an exaggerated scale on the architectural elements and costumes throughout the design. However, Hockney expanded on the usual monochrome of graphic work by introducing colour, though based on the standard printing colours of the period: red, blue, green and black. In directly

referencing the eighteenth-century work, Hockney mirrored Stravinsky's approach to the score, which was written in a classical mode looking back to the age of Mozart. In addition, Hockney's design compliments the jagged linear character of Stravinsky's music.

Hockney's research into the work of Hogarth for the production of these designs led him to produce the painting *Kerby (after Hogarth) Useful Knowledge* (1975), in the collection of the Museum of Modern Art, New York. Based on Hogarth's print *Satire on a False Perspective* 1754, it presents, at first glance, a harmonious rural scene. However, on closer inspection one notices that the false use of perspective causes many anomalies, such as figures in the foreground impossibly interacting with those in the background. *Kerby*, and the influence of the print by Hogarth, marked a key moment in the development of Hockney's art. The treatment of space is entirely subjective and the traditional values of perspective are suspended, yet the painting remains convincing in its verisimilitude. This was to be a feature of much of Hockney's subsequent work. TB

FIGURE 20
Design for the Drop Curtain
ARTS COUNCIL

FIGURE 21
Brothel Scene from
The Rake's Progress
*as performed at
Glyndebourne Festival
Opera* 1975 (Tom
Rakewell: Leo Goeke;
Mother Goose: Thetis
Blacker; Nick Shadow:
Donald Gramm)
ARTS COUNCIL

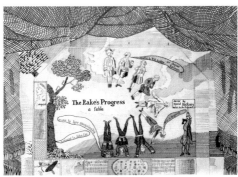

FIGURE 20

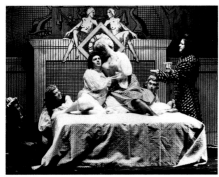

FIGURE 21

12

Paula Rego (born 1935)
The Betrothal: Lessons: The Shipwreck, after 'Marriage a la Mode' by Hogarth 1999
Overall display 165 × 500
Pastel on paper and aluminium
TATE. PURCHASED WITH ASSISTANCE FROM
THE NATIONAL ART COLLECTIONS FUND
AND THE GULBENKIAN FOUNDATION 2002

Born in Lisbon in 1935 and trained at the Slade School of Art, London, from 1952 to 1956, Paula Rego first attracted widespread interest in Britain following a retrospective exhibition of her figurative painting in London in 1988. As a painter and graphic artist, Rego's work is narrative in its format, her imaginative subjects drawn largely from childhood memories, nursery rhymes, fantasy and fairy tales. Difficult and controversial scenarios from human experience often feature in her work, such as the *Abortion Series* (1999), powerful and haunting in its emotive charge.

The Betrothal: Lessons: The Shipwreck, after 'Marriage a la Mode' by Hogarth, a large-scale pastel triptych, was produced by Rego for the exhibition *Encounters: New Art from Old*, held at the National Gallery, London, in 2000. The exhibition curators invited contemporary artists to make new work in response to paintings in the National Gallery collection, and Paula Rego chose Hogarth's *Marriage A-la-Mode*. The artist takes the theme of the narrative, an arranged marriage, and transposes it to her native Portugal in a time curiously mixing the 1950s and 1980s.

The left-hand panel, *The Betrothal*, is based on the first painting in Hogarth's series, *The Marriage Settlement*. Rego shows the mothers brokering the marriage (rather than the fathers, as in Hogarth's original) with the husband overlooking the events reflected in the mirror. The social structure is also reversed, as here it is the girl's family who have fallen on hard times, the boy's nouveau-riche mother having been the former maid. The young intended bride slumbers in a red armchair, while her prospective groom in his best suit crouches behind his mother, clinging to her protectively. As with Hogarth's original painting, the boy and the girl, the two protagonists of the proposed marriage, show no interest in each other whatsoever. An image in the background indicates what the future holds for this ill-arranged relationship, devoid of affection or respect – a scene in which a girl is raped by her suitor.

The central panel, *Lessons*, refers to Hogarth's fourth painting in the series, *The Toilette*. Hogarth's scene of hair crimping is transposed to a modern-day beauty parlour where the girl's mother is having her hair done. The daughter looks admiringly at her mother in the mirror, seeing in her what she hopes she might become. The mother takes a controlling influence over the education of her daughter, teaching her all she needs to know about looking good – the 'tricks of the trade', so to speak. As the artist has commented, 'My scene differs from Hogarth's ... because the girl is not yet married. She is still learning.'[43]

The right-hand panel, *The Shipwreck*, is based on Hogarth's fifth painting of the series, *The Bagnio*. The tragic scene of Hogarth's painting in which the earl is killed is represented by the artist as a contemporary *pietà*, the pathetic figure of the husband cradled by his wife as she sits in their desolate dwellings. The story has moved on some time and things have changed considerably, the dreadful condition of the room symbolising the state of their relationship. They are shown alone, the family that brought them together having deserted them in their hour of need. Rego explains:

In my story what has happened is that he's spent all their money. There they are in the leftovers of what they own. They've had to sell the rest of the property ... Anyway, everything has been dissipated. But, despite the misfortune, she's holding him on her lap to comfort him. The blind cat's there to defend them against the world. In Hogarth's last scene, The Lady's Death, the Countess kills herself, but my woman is left to do the clearing up and get things back to normal.[44]

TB

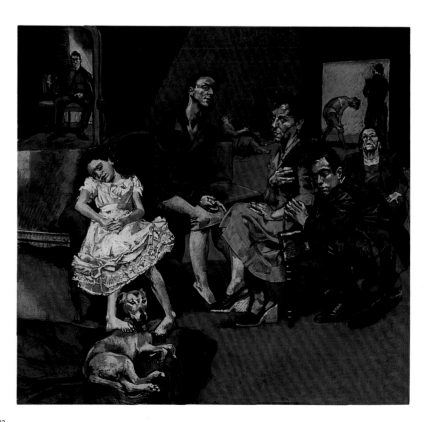

12

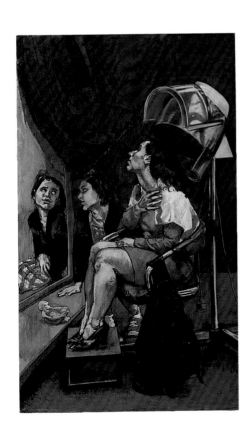

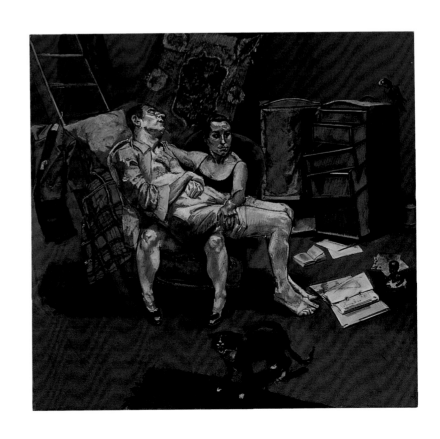

13

Yinka Shonibare (born 1962)
Diary of a Victorian Dandy: 11.00 hours, 14.00 hours, 17.00 hours, 19.00 hours, 03.00 hours
1998
C-type photographic prints, each 183 × 228.6
COLLECTIONS OF PETER NORTON AND EILEEN HARRIS NORTON, SANTA MONICA. COURTESY OF STEPHEN FRIEDMAN GALLERY, LONDON AND JAMES COHAN GALLERY, NEW YORK

Yinka Shonibare grew up in London and Lagos, Nigeria, and in 2004 was nominated for the Turner Prize. Much of his work focuses on notions of representation and identity, mediated through the art and culture of the eighteenth and nineteenth centuries, for example in his installation *The Swing (after Fragonard)* (2001; Tate). In 1998 Yinka Shonibare was commissioned by the Institute of International Visual Arts (InIVA) to produce a new work to be

displayed on the London underground. This resulted in the series of five photographs collectively known as the *Diary of a Victorian Dandy*. Among other influences, the work is loosely based on Hogarth's earlier series *A Rake's Progress*. However, Shonibare inverts traditional modes of representation by casting himself, a black man, in the central role of the dandy. As with Hogarth's original, the series is a progressive narrative tale. However, rather than stretching over an extended period of time, the events happen within one day. In this respect it mirrors Hogarth's other series, *The Four Times of Day* (no.67).

Diary of a Victorian Dandy begins with *11.00 hours* showing the dandy in his sumptuous bed as he awakens late in the morning, a number of chamber maids and a valet attending to his every need. By *14.00 hours* he is in an impressive library, centre stage, holding forth among his admiring

friends. *17.00 hours* shows a similar scenario, this time set in the billiard room – the dandy sparring with a fellow in sport and his contemporaries looking at him in awe. Later that evening, at *19.00 hours*, the dandy has the ladies and gentlemen of the household captivated in the opulent drawing room, entertaining them following dinner. The early hours of *03.00 hours* descend into an orgiastic scene of sexual excess and abandon, a time that Hogarth had previously chosen for Scene 3 of *A Rake's Progress*. This, too, is a scene of debauchery. All the scenes are highly orchestrated and finely composed, the exaggerated gestures and postures of the figures mirroring the theatricality of Hogarth's work.

Unlike Hogarth's version it does not represent the decline and fall of the individual portrayed, but revels in the leisure, opulence and luxury of the events and environment. It therefore does not share

13 11.00 HOURS

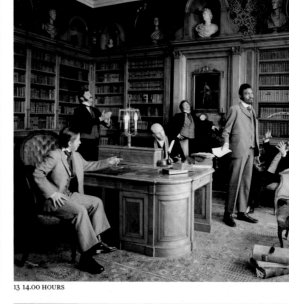

13 14.00 HOURS

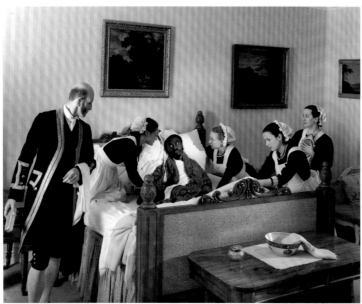

13 17.00 HOURS

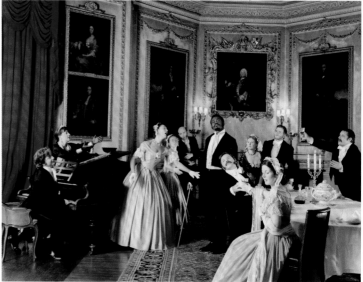

13 19.00 HOURS

Hogarth's overt moral message conveyed through the actions of the main character, but the presence of the central black figure suggests other issues at work in the decadent display. From the early eighteenth century Britain became increasingly rich from its imperial activities, reaching its apogee in the late nineteenth century. The epicurean world that the dandy occupies displays the fruits of the empire, from the silks of ladies' gowns to the ivory billiard balls in the games room. Much of this wealth was underpinned by the lucrative trade in African slaves and the highly profitable businesses, such as sugar production, to which it was linked.

The unusual figure of the black dandy highlights the contrast in the ordinary experience between the races in this period, and the disparity in social and economic standing between blacks and whites. The position of the vast majority of black people in society is reflected in their representation

in eighteenth-century paintings, including Hogarth's, where they are seen by the artist as generally anonymous and part of the crowd. Shonibare overturns this hierarchical tradition, moving the black man from the periphery to centre stage. As the artist himself has stated:

In Diary of a Victorian Dandy, I wanted to explore the history of the representation of black people in painting, who usually occupied not very powerful positions, as in Hogarth's work. Therefore, in my photographic tableaux I wanted to recreate a history of art from fantasy, where interpreting the role of the protagonist I used my own image of a black person in order to reverse the state of things.[45]

TB

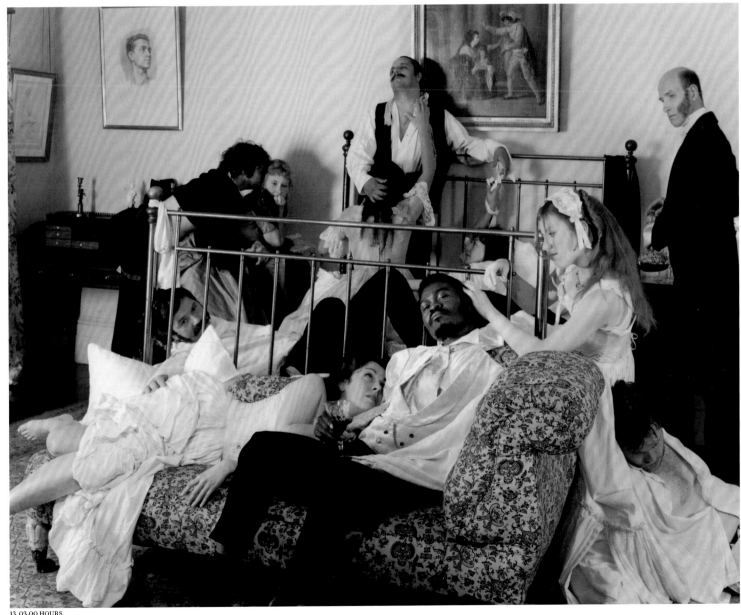

13 03.00 HOURS

2
Pictorial Theatre: The 1720s

Mark Hallett

On 12 June 1730 the jobbing poet Joseph Mitchell finished writing the first of three 'Poetical Epistles' celebrating 'Masters in the Art of Painting' in England.[1] The poem, which was published the following year, was devoted to the art of William Hogarth. Mitchell's piece confirms that Hogarth, only a decade after setting up as an independent artist in London and two years before the display and publication of his celebrated *Harlot's Progress*, was already being fêted as a leading artist in the capital. Mitchell declares that

> Self-taught, in your great art excel,
> And from your rivals bear the Bell

and goes on to laud Hogarth's brilliance at capturing facial expression, his unique fusion of Dutch and Italian pictorial styles, and his sensitivity to all aspects of contemporary society:

> Painting alone is not your Praise
> You know the World, and all its Ways.
> Life, high and low, alike command,
> And shew, each work, a Master-
> Hand.[2]

However hyperbolic, Mitchell's verses usefully indicate the range of skills admired in Hogarth, and the variety of subjects – both high and low – that he was seen to have successfully tackled. This remarkable versatility was only partly the product of Hogarth's own innate abilities, however. It was also the result of an artistic training and development that had been unusually diverse, and that produced someone who, by the time Mitchell had penned his poem, had become exceptionally adept in two quite distinct artistic spheres.

Hogarth began his career as an engraver, and in his late, unpublished 'Autobiographical Notes' he declared that 'engraving on copper was at twenty [my] utmost ambition'.[3] Having spent a number of years apprenticed to the silver plate engraver Ellis Gamble, Hogarth achieved his goal in 1720. In that year, at the age of twenty-two, he opened his own shop and studio, and published his own trade card, proudly emblazoned 'William Hogarth, Engraver' (no.14). The world of printmaking that he was now entering was crowded and competitive, geared to a city in which the display of graphic art was one of the backdrops of everyday life. London was full of places where prints were exhibited, perused and purchased. Printshops and bookshops dotted the centre of the city,

spilling their graphic wares out onto the capital's streets. Coffee houses regularly held print auctions, in which thousands of locally produced and imported etchings and engravings were exhibited and sold. Finally, English and European engravers working in the capital typically ran shops making their work available to passers-by. This world of graphic art was not only highly visible at street-level; it expressed itself on a daily basis in the capital's newspapers, where individual prints, and sales of prints, were continually being advertised and described, often in great detail.[4]

In making his way within this environment, Hogarth, as well as producing the kind of work that was typical of his profession – book illustrations, trade cards and the like – soon began to specialise in graphic satire. This particular genre of printmaking, long established in London, typically combined humorous, acidic commentary on contemporary issues with a highly eclectic form of pictorial practice, often involving the witty juxtaposition of different visual and textual materials drawn from a wide range of sources. Graphic satire allowed the individual engraver an unusual degree of artistic independence and creativity, offering as it did an alternative to the more conventional task of reproducing existing images, whether painted or engraved. The graphic satire that Hogarth produced in the 1720s saw him engaging with the great social and political issues of his time, ranging from the South Sea Bubble crisis to the fashionable craze for masquerades, and developing a highly experimental and self-consciously allusive form of printmaking. This kind of satire also helped him gradually build a distinctive reputation within the world of printmaking, so that by the end of the decade he was widely recognised as someone whose graphic art, in the words of contemporary newspaper advertisements, was especially 'diverting', 'rare' and 'curious'.[5]

As well as pursuing his ambitions as an engraver during the 1720s, Hogarth entered the world of painting, which enjoyed a similarly cosmopolitan and urban character to that of printmaking. The painters based in London in the opening decades of the eighteenth century made up a relatively small community of native and foreign-born artists. In the absence of any substantial form of court, state or religious patronage, and in the face of a strong degree of prejudice about the worth of locally produced painting, this community sought

A Scene from
'The Beggar's Opera' 1731
(no.39, detail)

to advance its artistic status and commercial profile through the formation of informal academies of painting in the capital. At the Academy of Painting in St Martin's Lane, which he joined soon after setting up shop as an engraver, Hogarth had the opportunity not only to become adept in a new art form but also to learn the etiquette and manners required for success in a milieu that tended to be more urbane than that centred around the engraver's workshop. The Academy was a gentleman's club as much as it was a teaching institution, and there a young artist such as Hogarth had the chance to rub shoulders with established painters, meet visiting connoisseurs and woo potential patrons.[6]

Towards the end of the decade this alternative, more informal kind of apprenticeship began to pay off for Hogarth, as he started selling paintings as well as prints. Significantly, these were not for single-figure portraits, which most aspirant painters tended to specialise in, but for rather more innovative types of work. They include paintings such as *The Denunciation* (no.35) and *The Christening* (no.36), which fuse the traditional vocabulary of Dutch genre painting with the contemporary preoccupations and forms of pictorial satire. Such paintings are noticeable not only for their darkly comic focus on deviant sexuality, professional corruption and fashionable excess but also for their concentration on highly theatrical forms of legal and religious exchange, in which groups of spectators gather around men and women acting out choreographed forms of ritual. This kind of pictorial theatricality – something that is also a distinctive feature of the graphic satires produced by Hogarth in the first decade of his career – was made even more explicit in another type of canvas produced by the artist at the end of the decade: paintings such as *Falstaff Examining his Recruits* (no.37) and the famous *Beggar's Opera* series (nos.38–9) in which Hogarth painted subjects drawn from canonical and contemporary drama. These theatrical pictures established an entirely new genre within English painting, in which, for the first time, the dramatic works of writers such as William Shakespeare and John Gay were translated into painted form. At the same time they reveal the rapid development of Hogarth's skill in using the human figure to create intricate, flowing forms of pictorial narrative and see him promoting himself as both an exceptionally inventive pictorial satirist *and* a highly refined painter.

14

Shop Card 1720
Engraving
7.6 × 10.2
THE BRITISH MUSEUM, LONDON

14

The trade card was a ubiquitous feature of commercial life in eighteenth-century London, and Hogarth was to produce a number of such cards in the early years of his career. As well as announcing his entrance into the London print market in the spring of 1720, his own card functioned to advertise his skills as a 'penman', a term used by contemporaries to denote someone who was equally adept at engraving lettering and imagery. His name and profession are inscribed with a calligraphic flourish, and are surrounded by pictorial details suggestive of elegance, learning and invention. The gracefully posed figure of Art and the intellectually active figure of History stand on either side of the card; a cherub signifying Design holds aloft an architectural drawing; and a richly gilded frame is adorned with heavy swags, two sculpted heads, and an elaborate cartouche. However modest in scale and significance compared to his later work, this card has an allegorical and decorative richness that suggests the unusual extent of Hogarth's artistic ambitions right at the beginning of his career.

15

Ellis Gamble's Shop Card c.1723
Engraving
7.5 × 6
ANDREW EDMUNDS, LONDON

Before embarking on a career as an independent engraver in 1720, Hogarth had been apprenticed to the silver-plate engraver Ellis Gamble, from whom he learnt many of the basic skills of his craft. Although the younger artist broke off his apprenticeship before it was due to end and turned to the more promising activity of copperplate engraving, his production of this trade card in 1723 suggests that relations between the two men remained cordial. In this handsome card, which announces his old master's advance to the status of a 'goldsmith', Hogarth depicts the 'Golden Angel' that identified Gamble's premises and that was presumably to be found standing above the shop's exterior. Hogarth's increasing facility with the engraver's burin is demonstrated by the stipple on the angel's neck and the cross-hatching that shadows her wing, as well as by the variety of line he uses for the clouds that scud across the background. The French text that occupies the right-hand side of the caption, and that aligns Gamble with the prestigious community of Huguenot goldsmiths who had settled in London, indicates the extent to which Hogarth's career developed in the context of a cosmopolitan urban culture crowded with European artists and artisans.

15

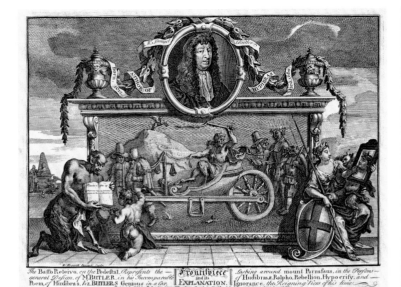

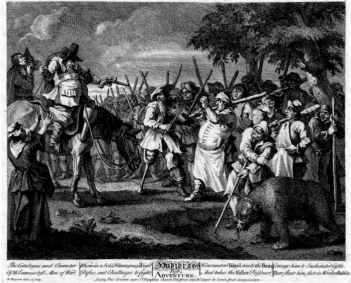

The Basso Relievo, on the Pedestal, Represents the — *Frontispiece* Lashing around mount Parnassus, in the Persons — general Design, of M.BUTLER, in his Incomparable *and its* of Hudibras & Ralpho, Rebellion, Hypocrisy, and — Poem, of Hudibra's, Viz BUTLER'S Genious in a Car. *EXPLANATION.* Ignorance, the Reigning Vices of his time.

Printed & Sold by P. Overton near S.t Dunstans Church in Fleetstreet & I. Cooper in James Street Covent Garden.

28

The Catalogue and Character *Hudibras's* Whom in a bold Haranguing Knight Encounters Talgol, routs the Bear, Convoys him to Enchanted Castle. Of th' Enemies lost, Men of War; *First* Defies, and Challenges to fight: And takes the Fidler Prisoner, there shuts him fast in Wooden Bastile. *ADVENTURE.*

W. Hogarth delin. et sculp.

Sold by Phil Overton, near S.t Dunstans Church Fleetstreet and Iа Cooper in James Street Covent Garden.

29

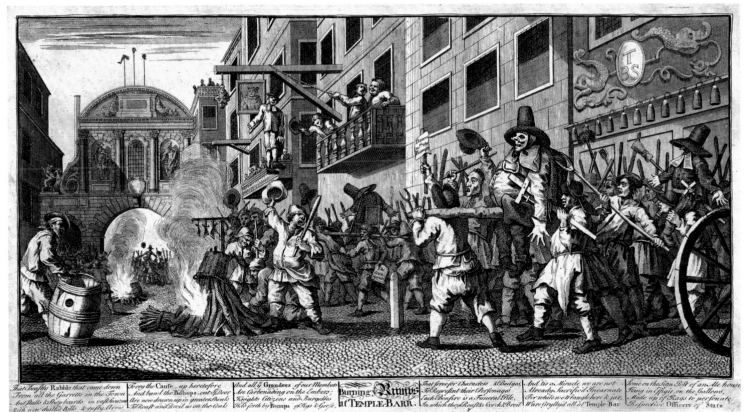

That beastly Rabble that came down From all the Garrets in the Town And Stalls & Shop-boards in vast Swarms With new chalkt Bills, & rusty Arms From ev'ry Cause up heretofore And bawl the Bishops out of Door Are now drawn up in greater Shoals To Roast and Broil us on the Coals And all y.e Grandees of our Members Are Carbonading on the Embers; Knights Citizens and Burgesses Held forth by Rumps of Pigs & Geese, *Burning y.e Rumps at TEMPLE-BARR.* That serve for Characters & Badges To Represent their Personages, Each Bonfire is a Funeral Pile In which they Roast & Scorch & Broil And tis a Miracle we are not Already Sacrific'd Incarnate For while we Wrangle here & jar Ware Grylld all at Temple-Bar Some on the sign Post of an Ale-house Hang in Effigie, on the Gallows, Made up of Rags to personate Respective Officers of State

34

35

The Denunciation 1729
Oil on canvas
49.5 × 66
NATIONAL GALLERY OF IRELAND, DUBLIN

36

The Christening (Orator Henley Christening a Child) c.1729
Oil on canvas
49.5 × 62.8
PRIVATE COLLECTION

Painted at roughly the same time and displaying strikingly similar themes and dimensions, these two works may well have been painted as companion pieces: that contemporaries thought this was the case is suggested by the publication in the early 1730s of a pair of prints after the two canvases by Joseph Sympson Jr. In their shared focus on professional misconduct, false witness, sexual immorality, marital discord and effeminacy *The Denunciation* and *The Christening* images signal many of the preoccupations that were to feature in Hogarth's later, more famous pictorial series: in this instance the two pictures work together to condemn the corruption that can attend the conception and christening of a child.

In *The Denunciation* a pregnant unmarried woman stands before a magistrate and falsely declares that the father of her unborn child is the dour, miserly dissenter who stands nearby with

his arms and eyes raised theatrically upwards. While the wrongly accused man is berated by his enraged wife, his accuser – who may well be a prostitute – is being coached in her performance by the whispering figure of the real father, who trains her up just as the girl sitting next to the magistrate trains up her puppy. We are invited to imagine that the venal Justice – described in Sympson's print as someone who 'makes his market of the trading Fair' (that is, makes money out of exploiting prostitutes) – will declare on the pregnant woman's behalf, having already come to some kind of financial arrangement with her; significantly, Sympson's engraving concludes: 'The Jade, the Justice and Church Ward'ns agree, and force him [i.e. the accused man] to provide Security.'[10] As so often in Hogarth's works, the canvas is crowded with an array of supporting actors: the intimately posed pair of fops who watch the scene while whispering and sniffing a flower; the line of other dubious, flirtatious women who await their turn to appear before the corrupt magistrate; and the figures who try to push through the distant doorway.

In *The Christening*, meanwhile, the role of the deviant worthy is taken by what Sympson describes as the 'wanton' clergyman standing at the centre of the picture, who is distracted from his duties by the sight of the bosom of the young woman standing next to him.[11] Around this central

pairing Hogarth introduces a gallery of types familiar from *The Denunciation*: another mother, this time sitting in the background, who is once again being whispered to by a man who may be the father of her newly born child; another fop, who exaggeratedly admires himself in a mirror; another young girl, who clumsily spills the christening bowl; and another small dog, who worries away at the hat that lies on the floor. Such eloquent details helped make this kind of painted satire instantly successful, as is confirmed by the contemporary chronicler of the London art world, George Vertue, who noted in 1729 that 'a small piece of several figures representing a Christening being lately sold at a publick sale for a good price got him [i.e. Hogarth] much reputation'.[12]

35

3
The Harlot and the Rake

Christine Riding

A Rake's Progress
Scene 3 *The Rake at the
Rose Tavern* (no.44,
detail)

FIGURE 22
Boys Peeping at Nature
(second state) 1730
The print served as the
subscription ticket to
A Harlot's Progress
THE ROYAL COLLECTION,
THE ROYAL LIBRARY,
WINDSOR

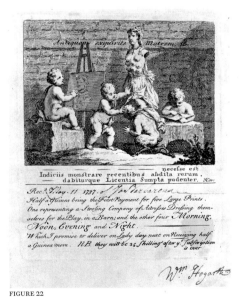

FIGURE 22

At some point in the early 1730s Hogarth turned to a category of art that was to bring him wealth and celebrity. Later in life he described this significant artistic development as a 'new way of proceeding, viz painting and Engraving *moder*[*n*] *moral subject*[*s*] a Field unbroke up in any Country or any age'.[1] While he overstated the absolute novelty of his 'modern moral subjects', the formula of a sequence of scenes that told a story of the artist's own invention but was anchored in contemporary life was indeed ground-breaking. As recorded by George Vertue, the concept came to Hogarth in a piecemeal fashion, beginning with 'a small picture of a common harlot, supposed to dwell in drewry lane, just riseing about noon out of bed, and at breakfast, a bunter waiting on her'. According to Vertue, 'this whore's desabille' and her 'pretty Countenance & air' was so admired by the (male) visitors to Hogarth's studio that 'some advisd him to make another, to it as a pair. which he did. then other thoughts encreas'd, & multiplyd by his fruitful invention, till he made six. different subjects which he painted so naturally ... that it drew every body to see them.'[2]

This 'small picture' was thus the starting point for *A Harlot's Progress*, which focused on the life of Moll Hackabout, a fictional London prostitute. The paintings were completed in 1731, by which point subscription for engraved versions had been advertised (fig.22). The subsequent clamour resulted in the purchase of 1,240 sets. That Hogarth's series had caught the public's imagination well beyond the collectors' market was underlined by the numerous pirated versions commissioned by opportunistic printsellers, as well as printed descriptions (at least one of which was pornographic) and literary and theatrical responses, including *Mr Gay's Harlot's Progress*, published in 1733, and Theophilus Cibber's *The Harlot's Progress; or, the Ridotto al'fresco*, staged at the Theatre Royal, Drury Lane, in the same year. Hogarth followed this runaway success with *A Rake's Progress* (no.44), which was similarly fêted. The series, incorporating eight individual images, charted the dissolute life and ignoble demise of another fictional character, Tom Rakewell, the unprincipled son of a wealthy middle-class financier who pursued the lifestyle of an aristocratic roué. In order to stymie pirate versions, Hogarth delayed publishing the prints until the Engravers' Copyright Act (popularly known as 'Hogarth's Act')

became law on 25 June 1735.[3]

With the harlot and the rake, Hogarth had selected two social archetypes, whose interwoven 'professions' and habitual environments were sleazy, perverse and thus fascinating to a wide social spectrum and, of course, rich with satirical possibilities. In part, the success of Hogarth's *Progresses* was thus a straightforward case of prurience and voyeurism. Irrespective of his audience's personal experiences, Hogarth in a masterly way presented each scene with a realism and intimacy that established his artistic identity as the roving satirist who observes with an unflinching eye the seedier side of London life. Indeed, Hogarth clearly relished portraying its evident temptations while exposing the absurdity and hypocrisy of its protagonists. This is particularly true of the third scene of *A Harlot's Progress*. Hogarth's alluring image of a pretty young prostitute seated on her bed in a state of undress, gazing out at the viewer, was clearly calculated to titillate his male visitors. However, Hogarth counteracts the salacious pleasure of contemplating Moll Hackabout as a desirable and willing sexual conquest by weaving into the narrative a series of male characters including a clergyman, a rake, a middle-class parvenu, a magistrate, a gaoler and two doctors, who collectively exploit and punish her, and fail to offer her protection or a guiding hand, or even to alleviate her suffering. While Moll and Tom are flawed in themselves, Hogarth makes it clear that they are by no means alone as transgressors within a world that is, by turns, self-serving, indifferent and unforgiving.

Hogarth's interpretation of the life of a prostitute and a rake thus encourages a variety of reactions in the spectator: prurience, derision, disgust and perhaps pity. Even Tom, who is more blatantly the architect of his own downfall, can inspire the love and loyalty of the long-suffering Sarah Young and cannot, therefore, be beyond our compassion as he slides into poverty and madness. But Hogarth's *Progresses* were also remarkable for absorbing, reworking and subverting prevailing stereotypes and narrative formulas. The wide variety of printed material such as biographies of celebrated prostitutes and whore directories underlines the schizophrenic attitude towards prostitution and deviancy in general in the eighteenth century. While the courtesan or kept woman (a position held by Moll Hackabout in the second scene)

FIGURE 23
Anonymous
A Rake's Progress 1732
THE BRITISH MUSEUM,
LONDON

FIGURE 24
Peter Lely (1618–80)
*Elizabeth, Countess of
Kildare* c.1679
TATE. PURCHASED 1955

But three Days past — Oh! Needles, poynts of Pins,
My Back — My Head — My XXXX Oh! my Shinns,
Lets see my Shirt Oh! Spots of Green and Yellow
What will my Father say — A Pretty Fellow.

FIGURE 23

convicted for the rape of a maidservant in his employ. Among the numerous satires that were published before and after his death in 1732 we find *Scotch Gallantry displayed: or the life and adventures of the unparrel'd* [*sic*] *Colonel Francis Charteris* (1730) and *Don Francisco's descent to the Infernal Regions, an Interlude* (1732), which cast him as a contemporary Don Juan.

When Hogarth embarked on his second *Progress* in 1733, 'the rake' was a long established embodiment of masculine waywardness and depravity. An inveterate consumer and 'man of leisure', the rake of convention fritters his fortune, usually inherited, on sex, drink, gambling and other entertainments. Along the way he amasses lavish debts and seduces, impregnates and abandons at least one young woman, often resulting in her financial and social ruin. As with the prostitute, a literary convention had developed in which the rake starts life as an impressionable young man from the country who comes to the city after inheriting money and swiftly embarks on a dissolute life. His typical fate was venereal disease, debtor's prison and death. Hogarth's series was pre-empted by the publication of an illustrated poem in 1732 entitled *The Rake's Progress, or Templar's Exit* (fig.23). The rake of the title, diseased and destitute, commits suicide by hanging from a nail on which hangs a framed print of Scene 3 of *A Harlot's Progress*:

Thus like a Hero Dick did swing,
A prettier Spark ne'er grac'd a String;
And till the am'rous Youth was
 strangled,
Beneath Moll Hackabout he
 dangled.[4]

Such bleak storylines were complemented by conversion narratives, an example being *The Rake Reform'd*, a poem published in 1717, where the main protagonist realises the error of his ways and retires to the country. And the reformed rake resisting the temptation of his previous life was used to comical effect in John Vanbrugh's ironically titled play *The Relapse, or Virtue in Danger* (1696). However, while Tom rails against his fate and eventually despairs, he is not repentant and doggedly ignores the possibility of salvation as represented by his abandoned lover Sarah. Indeed, his persistence as a rake would be almost heroic, if it were not so spectacularly foolish.

In fact Tom is a conflation of male types over and above 'the rake'. A middle-class

could achieve a degree of respectability, being 'exclusive' and historically associated with royalty and aristocracy, those in brothels and on the streets tended to be characterised as vain, artful temptresses who were, through their promiscuity, directly responsible for moral corruption and the spread of disease. Very rarely was such an onus put on their clients, however. Hogarth's image of Moll in Scene 3 thus underlines the perceived danger of the prostitute, whose outward desirability disguised a body already corrupted by venereal disease. This sense of menace is played out in Scene 3 of *A Rake's Progress*, when Moll and Tom's worlds intermingle.

A Harlot's Progress burst onto the London scene just after an official crackdown on prostitution had been instigated, focusing specifically on Covent Garden. The most prominent figure in this initiative was Justice John Gonson, whose missionary zeal

in 'cleaning up' the streets was regularly reported in the London press. By the 1730s the emphasis on blame and revulsion was partially tempered by a journalistic convention that promoted 'the prostitute' as an innocent country girl who arrives in the city, alone and vulnerable, and is tricked into prostitution by a devious brothel keeper. Hogarth incorporated these inconsistent representations into *A Harlot's Progress*, giving them greater resonance and topicality by folding into the storyline references to real-life characters, including Gonson himself. In Scene 1 Moll is met by Elizabeth 'Mother' Needham, a notorious brothel keeper who died in 1730 after being brutally assaulted by the London crowd as she stood in a pillory, a form of corporeal punishment. In the background stands Colonel Francis Charteris, an infamous Scottish rake nicknamed 'The Rape-Master General of Britain'. In March 1730 he was

male aspiring to be an aristocrat was known as a 'cit'. And Tom's inordinate concern with outward display finds parallels with 'the fop'. His pretensions and self-delusion in assuming a lifestyle above his class are mercilessly lampooned by Hogarth throughout the series via absurd juxtapositions between himself and, for example, classical deities and Roman emperors. An equally absurd parallel was that of the Restoration rake, most famously John Wilmot, 2nd Earl of Rochester, who, in addition to being a libertine, was a celebrated wit, courtier, man of letters and patron of the arts. Thus we find Tom not only conforming to the profile of the carousing rake but at various moments patronising musicians and poets, going to an audience at court and even writing a play.[5] The ironic allusion to the glamorous, promiscuous and cynical court of Charles II is evident in *A Harlot's Progress*. Moll's representation in Scene 3, which made such an impression on Hogarth's clients, clearly mimics the air of indolent languor and sleepy-eyed beauty characteristic of late seventeenth-century court portraiture. Provocative and openly sensual, with fashionable undress and low décolleté, such images were most closely associated with royal mistresses such as the actress and prostitute Nell Gwyn; Louise de Kéroualle, Duchess of Portsmouth; and Elizabeth, Countess of Kildare (fig.24). In this context we might interpret Moll in Scene 3 as an eighteenth-century 'male fantasy figure'. However, despite her consummate play-acting, she is not glamorous or exclusive but a common prostitute, available to anyone with the cash.

Such wide and varied visual, literary and cultural references, past and present, underline how rich and innovative Hogarth's *Progresses* would have seemed to his contemporaries. They also signal his personal crusade to establish modern urban life, including low life, as an appropriate subject for high art. Via the *Progresses*, Hogarth presented himself as both the roving satirist and an intellectual, gentleman artist. This is evident from the titles themselves. Hogarth's use of the word 'progress' would have immediately recalled John Bunyan's *Pilgrim's Progress* (1678 and 1684), which is thought to have been the most widely read book after the Bible in early eighteenth-century England. The story is a Puritan conversion narrative in which the progress of Christian, the main protagonist, constitutes an allegorical journey from burden to freedom, via

FIGURE 24

various trials and conflicts (Bunyan's work was also significant in the development of satiric realism and use of name symbolism). In addition, the biblical associations and parable character of both *Progresses* – the Prodigal Son or the penitent Magdalen are obvious precedents – underscore Hogarth's ambitious approach. However, the positive connotations of 'progress' in terms of personal development and advancement are comically diverted by Hogarth into a relentless downward spiral.

40

Before and *After* 1730–1
Oil on canvas
Before 44.7 × 37.2
After 45.1 × 37.2
FITZWILLIAM MUSEUM, CAMBRIDGE

41

Before and *After* c.1731
Oil on canvas
Each 38.7 × 33.7
THE J. PAUL GETTY MUSEUM,
LOS ANGELES

42

Before and *After* 15 December 1736
Etching and engraving
Before 42.6 × 32.8
After 40.9 × 33
ANDREW EDMUNDS, LONDON

In the 1730s Hogarth produced three versions of paired works entitled *Before* and *After*. One of the painted sets was reputedly executed 'at the particular request of a certain vicious nobleman'.[6] The first of these had an outdoor setting, in which Hogarth parodied fashionable *fête galante* subjects by Antoine Watteau, Nicolas Lancret and others, as well as the *tableaux de mode* of Jean-François du Troy (see p.145). In *Before* we find an amusing scene of studied elegance with gallant persuasion on the part of the man and affected coyness on the part of the woman, the type of vignette that was common in *fête galante* compositions. Far from leaving the consequences to our imagination, Hogarth shows the young couple after sexual intercourse, mutually dishevelled and bewildered from their physical exertions, but importantly without the inference of exploitation. The *Before* and *After* format was to take a cynical turn, however, in the other series. The oil versions, this time with an indoor setting, were probably executed just after *A Harlot's Progress*. The engraved versions (with some changes and additions) were published in 1736, the year after those of *A Rake's Progress*. The *Before* scene, set in a lady's bedchamber, is violent, with the woman cast as a reluctant, even frantic prey, pushing over her dressing table in an effort to escape, and the man as a heartless predator pulling her towards the bed. In the painted version his red breeches with a strip of gold braiding strategically placed in his bulging

40 BEFORE

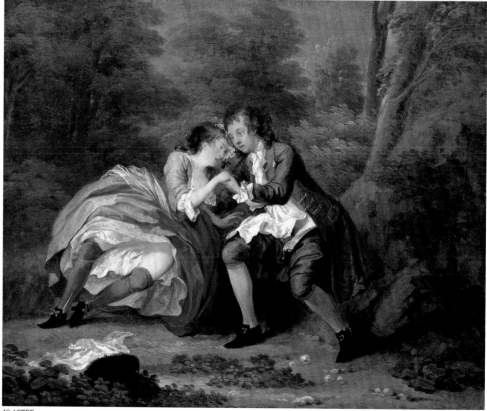

40 AFTER

4
Pictures of Urbanity: The Conversation Piece

Mark Hallett

In 1729 George Vertue noted in his journal that Hogarth was enjoying 'daily success ... in painting small family pieces & Conversations with so much Air & agreeableness [as] causes him to be much followd, & esteemd. wherby he has much imployment and like to be a master of great reputation in that way.'[1] A year later the same writer returned to Hogarth's abilities as a painter of 'family peices and conversations consisting of many figures. done with great spirit a lively invention & a universal agreableness'.[2] Vertue's comments alert us to the popularity and character of one of the most important and innovative branches of Hogarth's art, the conversation piece, which typically depicts groups of figures – often quite large in number – who have come together for some kind of convivial or familial occasion.[3] These works, which had their pictorial origins in Dutch and French group portraiture, tend either to picture the male and female members of a single family, often with their relations, friends, servants and dogs, or else to represent groups of male companions gathered affably together. The settings of such pictures, which range from grandly appointed ballrooms to fictionalised country estates, function as pictorial stages for particular kinds of sociable performance: as David Solkin has demonstrated in his book *Painting for Money*, Hogarth's conversation pieces show men, women and children acting and interacting according to the modern ideal of politeness.[4]

The concept of politeness emerged in this period as older, aristocratic models of identity and behaviour were adapted to take account of the appearance of a new kind of elite community – one made up not only of the traditional landed aristocracy but also of urbanised, commercialised and self-consciously modern individuals who were increasingly seeing themselves as central to the workings of contemporary society and culture. This new elite, and its philosophical, literary, journalistic and artistic spokesmen, promoted 'politeness' – a term associated with the virtues of a restrained, polished and tolerant sociability – as an all-embracing concept that promised to bring a hitherto fragmented society into harmony and allowed men and women of different characters and backgrounds to meet, talk and live together in a sphere of mutual exchange and respect. As the historian John Brewer has recently written,

'the aim of politeness was to reach an accommodation with the complexities of modern life and to replace political zeal and religious bigotry with mutual tolerance and understanding. The means of achieving this was a manner of conversing and dealing with people which, by teaching one to regulate one's passions and to cultivate good taste, would enable a person to realize what was in the public interest and for the general good. It involved learning a technique of self-discipline and adopting the values of a refined, moderate sociability.'[5]

Hogarth's conversation pieces see the values of 'refined, moderate sociability', 'good taste' and 'mutual tolerance and understanding' – values typically associated with the newly fashionable urban institutions of the coffee house, the assembly rooms and the club – being articulated in pictorial form and, in many cases, being extended into the realms of family life. The tenets of politeness come to suffuse the environments of the domestic interior, the garden and the estate. Within these settings Hogarth depicts the art of politeness being practised and demonstrated through particular kinds of social ritual: the drinking of tea among family and friends, which contemporaries lauded as a highly civilised and sociable pleasure open to both the male and female members of elite society; the playing of card-games like whist, which involved working closely with a partner and which one writer lauded as 'both genteel and allowable ... especially, when one plays rather for amusement than gain'; the appreciation of works of art, of books and of private forms of theatre; and, finally and most importantly of all, the ritual of conversation itself.[6] Through polite conversation, it was understood, affluent and educated individuals of both sexes were given the opportunity to prove their taste, wit and open-mindedness and to display their responsiveness to the preoccupations and accomplishments of their interlocutors. In so doing, such individuals acquired exactly that 'Air & agreeableness' noted by Vertue as a central characteristic of Hogarth's own painted conversations, which can now be seen as works that both depicted and embodied the good taste, the wit and the attentiveness to others that were considered to be the cornerstones of polite culture.

Significantly, the politeness found in Hogarth's canvases is not solemn or stiff, but tender, good humoured and animated. This concentration upon affectionate and

The Strode Family c.1738
(no.54, detail)

lively interaction points to another important context for Hogarth's conversation pieces. In those examples of the genre in which he focused on familial groupings – what Vertue called his 'small family pieces' – the artist was not only extending the rhetoric of politeness into the domestic realm. He was also responding to, and helping represent, a new 'affective' ideal of the family being developed in the period, one that promoted the family as an institution that also fostered the virtues of equable companionship, tolerance and sympathy. In Hogarth's family conversations, the benefits associated with the polished public sphere are fused with those that were simultaneously being seen to emanate from the everyday, intimate exchanges of family life itself.[7]

Finally, it is worth noting that the patrons Hogarth attracted for his conversations were drawn from a variety of backgrounds: they included not only aristocratic courtiers such as Sir Andrew Fountaine but also men whose wealth derived from the City of London: Richard Child, William Strode and William Wollaston, for whom Hogarth painted a conversation piece (fig.7, p.26) that Vertue described as being 'a most excellent work containing the true likeness of the persons, shape aire & dress – well disposd, genteel, agreeable'.[8] What also attracted such patrons, and what distinguished Hogarth's conversations from those produced by competitors such as Gawen Hamilton and Charles Phillips, was what Vertue praised as their 'great variety' and 'lively invention'.[9] The artist himself, looking back on his early career and remembering his portraits of 'subjects ... in conversation', noted that they 'gave more scope to fancy than common portrait'.[10] In these terms, what is most striking about Hogarth's conversation pieces is how they convey remarkably subtle forms of pictorial narrative: as well as painting vivid likenesses of his male and female subjects, the artist continually invites his viewers to decipher the intimate human events and encounters that unfold – or seem just *about* to unfold – within his heavily populated canvases and that are revealed and expressed as his subjects enjoy their convivial pleasures.

47

Woodes Rogers and his Family 1729
Oil on canvas
35.5 × 45.5
NATIONAL MARITIME MUSEUM, LONDON

This early example of Hogarth's group portraiture depicts the family of the famous British sailor and colonial administrator, Captain Woodes Rogers, who had recently been restored to the Governorship of the Bahamas after having been controversially relieved of this post earlier in the decade. In Mary Webster's words the picture was painted 'to celebrate this vindication of his past career in the Bahamas and his restored dignity'.[11] The painting is of a more awkward character than Hogarth's later conversations, suggesting that the artist, at this point, was still in the process of developing the format that would soon bring him so much commercial and critical success. The picture is organised in two uncertainly related parts, with a left half laden with an intimate, feminised imagery of elegant but informal accomplishment and a right half that, by contrast, is packed with the symbols of the captain's public achievements.

Woodes Rogers is portrayed in a fictional outdoor setting, sitting grandly in front of a monument inscribed with what he clearly saw as a highly appropriate motto: 'Dum Spiro Spero' (While I breathe, I hope). Next to him a globe signifies his circumnavigation of the world during the War of the Spanish Succession (1701–13). In the background the pictured bay is presumably that of Nassau, while the smoking warship reinforces the sitter's status as both a veteran maritime commander and someone who famously eradicated piracy from the seas around the Bahamas. On the other side of the canvas, meanwhile, the captain's daughter Sarah sits with a book on her lap and a pet spaniel by her side, and a maid stands with a tray of fruit behind her.

Bridging the two halves of the picture, Sarah's brother William, swathed in an ostentatiously flowing robe, ceremoniously presents his father with a map inscribed 'Part of the Island of Providence', which refers to the largest of the Bahamian islands, and thus to the territory to which Woodes Rogers was imminently returning. William, it seems, bears the burden of two rather different pictorial demands. On one hand, his actions and attributes reinforce and celebrate his father's successes, and indicate that he, too, will follow in his father's footsteps and become a public

figure – as actually turned out to be case. On the other hand, his presence together with that of his sister also suggests – if somewhat tentatively – the tenderness of the relationship between two siblings and their parent, and their shared pleasure in each other's company. In subsequent years this second, more sympathetic and sociable storyline was to play a far greater role in Hogarth's conversation pieces, while the artist was to abandon the former, more formal and public kind of narrative. Indeed, we can imagine that, if Hogarth had been given the chance to repaint the central figure in the late 1730s, he would have taken away that map and robe, and let William's face and hands do all the talking.

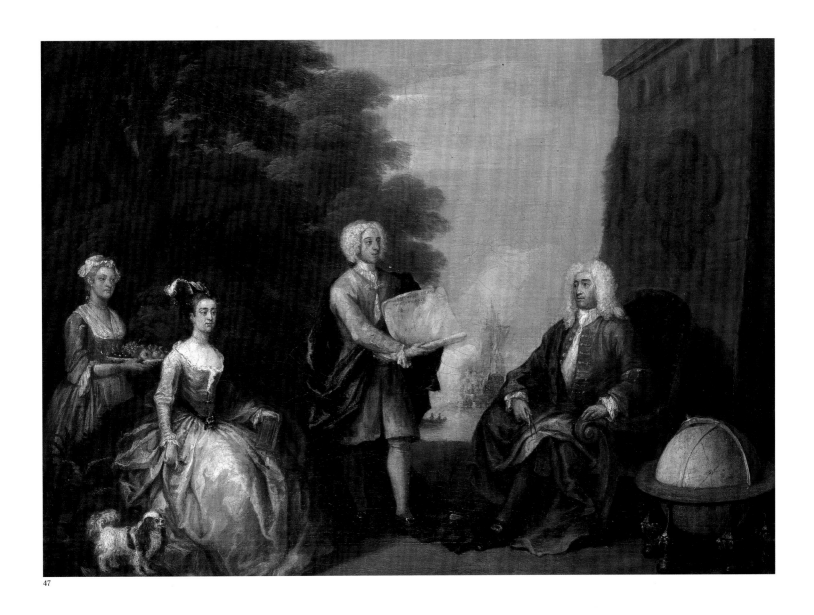

47

48

An Assembly at Wanstead House 1728–31
Oil on canvas
64.7 × 76.2
PHILADELPHIA MUSEUM OF ART. THE JOHN
HOWARD MCFADDEN COLLECTION, 1928

This painting was commissioned by
Richard Child, Viscount Castlemaine,
who was the heir to a substantial banking
fortune. Castlemaine had spent part of his
inheritance on a lavishly decorated house
at Wanstead designed by the Palladian
architect Colen Campbell. Hogarth's picture
is set in the long ballroom at Wanstead and
flaunts the luxuriousness of this interior –
the upper half of the picture space is
crowded with tapestries, sculptures,
paintings, furniture and extensive marble-
work. The lower half of the painting,
meanwhile, is populated by a dense array of
figures – twenty-five in all – whom Hogarth
studiously distributes across the full width
of the canvas. They are shown as having
gathered together to play cards and drink
tea in the late afternoon, accompanied by
their dogs and a household servant, who
is discreetly lighting a chandelier in the
distance.

The picture's most prominent figures are
Castlemaine and his immediate family: the
viscount's three youngest children, one of
whom sits on a poodle, are on the left; his
wife Dorothy is at the exact centre of the
composition, turning from the card-table
with an ace in her hand; and Castlemaine
himself, together with his two eldest
daughters, sits on the far right of the
picture. Hogarth, as well as foregrounding
these figures, links them together through
a subtle sequence of actions and looks. The
two boys on the left can be seen gesturing
towards, and seeking to gain the attention
of, their father; Castlemaine's wife similarly
reaches out to, and looks at, her husband,
while one of his two elder daughters gazes
affectionately at him as she pours tea. While
these details help reinforce Castlemaine's
patriarchal status as head of the family, it is
also noticeable that he deliberately relegates
himself to the picture's margins;
interestingly, it is his wife who occupies the
pictorial centre of Hogarth's canvas. This
ceding of pictorial authority might be linked
to the fact that, as Richard Dorment has
pointed out, this conversation piece was
probably commissioned to commemorate
the twenty-fifth anniversary of the
viscount's marriage to Dorothy.[12]
Significantly, a number of the art works
in the room celebrate wifely virtues and
steadfastness. Perhaps the painting was
intended to function at least partly as a
present to Dorothy from her husband,
and was therefore designed with a view to
giving her an unusual degree of pictorial
attention.

As well as highlighting their bonds as a
family, Hogarth's conversation piece subtly
integrates the viscount, his wife and their
children into the larger grouping of figures –
presumably a combination of other family
members and friends – who surround
them. Seen as a whole, the twenty-five
subjects of Hogarth's portrait are not only
linked by ties of kinship, marriage and
friendship but also by their shared
participation in the quintessentially polite
activities of tea-drinking and card-playing.
In this painting the privately resonant
exchanges between the viscount and his
family are embedded into the all-
encompassing flow of looks, gestures,
expressions and poses that binds the entire
assembly together and that – like a piece
of choreographed theatre – conveys the
allegiance of every depicted actor, from
Castlemaine onwards, to a collective ideal
of polite interaction. Here, it is worth
observing the way in which none of the men
and women stand or sit alone – instead, all
their bodies are shown overlapping each
other. Similarly, we can note the pictorially
interlocking sequence of hands, which
delicately point to, or rest on, other
members of the assembly, and study the
subtle interplay of expressions that convey
shared forms of ease, interest and affection.
Finally, it can be suggested that the picture,
however silent in reality, also asks us to
imagine the fusion of these people's voices
into the equable hum of elegant
conversation – one that fills the room with
the sound of politeness itself.

53

54

The Strode Family c.1738
Oil on canvas
87 × 91.5
TATE. BEQUEATHED BY REV. WILLIAM
FINCH 1880

In this heavily reworked, beautifully painted canvas Hogarth pares down the indoor conversation piece to its pictorial essentials: rather than the choreographed crowds and packed interiors of the *Assembly at Wanstead House* (no.48) or even of *The Indian Emperor* (no.53), we are presented with five elegantly interrelated figures placed in a refined and uncluttered interior. The most prominent figure, seated at the left of the depicted tea table, is Hogarth's patron, William Strode, who – like the patrons of the two earlier paintings – derived his wealth from the city. He is shown leaning across to his old tutor, Dr Arthur Smyth, who had accompanied him to Venice earlier in the decade and sits with an open book in his right hand. On the other side of the table sits Strode's new, aristocratic wife, formerly Lady Anne Cecil. The family butler, Jonathan Powell, replenishes the pot. On the right we see Strode's brother, Colonel Samuel Strode, standing stiffly by a doorway, a cane in hand. Two dogs are pictured on either side of the canvas, uncertainly eyeing each other up.

As well as commemorating Strode's recent marriage, this painting celebrates his learning and connoisseurship – here we can note the massed ranks of books lined up on his library shelves, and the three Italian paintings, including a view of Venice, that tower over Lady Anne. Just as importantly, Hogarth's work offers a pictorial distillation of the ideal of politeness or, rather, focuses on a moment that immediately precedes the realisation of this ideal. Politeness promoted conversation and other social pleasures like tea-drinking, as activities that brought people of different characters and backgrounds together into a harmonious whole: as long as every participant enjoyed a certain degree of wealth, refinement and learning, differences of temperament and rank could be temporarily suspended. Here we see Strode himself in the process of transforming this somewhat fragmented, disjointed group of people into such a polite unity. Thus Hogarth asks us to imagine him amiably entreating his non-aristocratic friend to abandon his admirable but rather pedantic and anti-social activity of reading, pull over his chair and join in with his more socially elevated companions in the convivial pleasures of conversation and tea. The straight-backed figure of Lady Anne, smiling blankly with a teacup in her hand, is poised for this conversation to begin, when we can imagine that she will become far more animated and engaged with those around her. The stiff figure of the colonel, meanwhile, is shown as if waiting for Smyth to join the table before he, too – on his brother's invitation – will sit in the empty yellow chair next to Lady Anne. Once he is there, it is implied, he will be able to shed the rather rigid, public persona of the army officer that he currently adopts, and enter the more informal and intimate realm of polite conversation.

Here, in contrast to pictures like *An Assembly at Wanstead House*, the ideal of politeness has been extended to incorporate the figure of the servant. Powell, although he is given a distinctly subservient role within the image, nevertheless takes his place within the semicircle of figures gathered around the table, a further sign, perhaps, of both Strode's benevolence as an individual and the inclusiveness of the polite culture that he embodies. This inclusiveness will also, of course, need to extend to the two very different dogs, which are pictured as if awaiting a proper introduction, just like their masters.

54

55

The Western Family 1738
Oil on canvas
71.8 × 83.8
NATIONAL GALLERY OF IRELAND, DUBLIN

This picture, which offers a perfect counterpart to *The Strode Family* (no.54) in its handling of figures, themes and paint, depicts various members of the Western family socialising with the clergyman – probably Archdeacon C. Plumptre – shown sitting on the right. As in the Strode painting, Hogarth captures the moment just before this group of individuals gathers together for tea. The artist's patron, Thomas Western, whom Hogarth had already painted in a single-figure portrait of 1736, is pictured carrying a trophy of the hunt and as wearing the hat that suggests he has just come in from outside. His wife Anne Callis, who is placed directly under the coat of arms that surmounts a distant doorway, stands expectantly at his side. Meanwhile, Western's mother, assuming the hospitable role played by William Strode in *The Strode Family*, reaches towards her son's bird with her right arm while simultaneously tugging at the robe of the sitting clergyman, who has become momentarily distracted by the entrance of a servant, to whom he gives instructions regarding a letter. The Western's young daughter peers over the tabletop, while in the background a servant returns his master's gun to its cover.

We are asked to imagine that, once the clergyman's attention has been captured and Western's bird has been admired by all, the bird – and the aggressively manly, outdoor and aristocratic pursuits that it symbolises – can be put to one side; then, we might reasonably expect, everyone – male and female, huntsman and clergyman, adult and child – will sit around the tea-table and enjoy both the drink and the conversation it stimulates. Once again, a collection of individuals of varying characters, ages and stations in life will have been turned, however temporarily, into a coherent, harmonious group. Hogarth provides an appropriately genteel set of props for this elegant storyline: the English harpsichord, ready to provide a suitably polished musical accompaniment when required; the ornately decorated, silvered tea-table; the intriguing screen, which is decorated with the imagery of a country house and gives the whole scene an especially theatrical air; and, finally, the painting hanging over the right-hand doorway, which, in a typically subtle touch by the artist, depicts the same kind of game that we see hanging from Western's left hand.

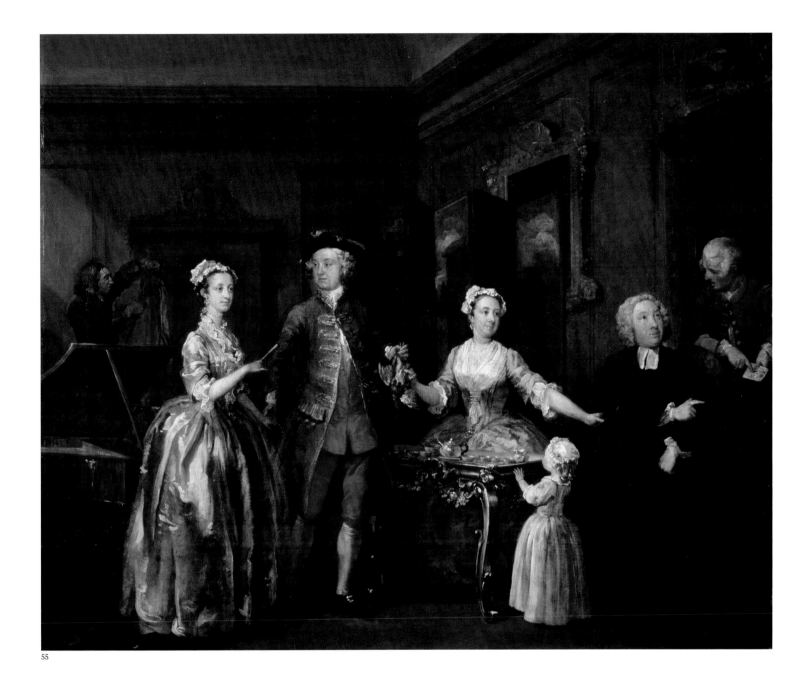

55

56

The Hervey Conversation Piece c.1740
Oil on canvas
101.6 × 127
ICKWORTH, THE BRISTOL COLLECTION
(THE NATIONAL TRUST)

This enigmatic group portrait was commissioned by John, Baron Hervey of Ickworth, seemingly to celebrate the political and personal companionship enjoyed by a small but highly influential coterie of Whig aristocrats, politicians and courtiers. Hervey, a well-known supporter of the Prime Minister Sir Robert Walpole and, at the time this picture was painted, Vice-Chamberlain of the King's Household, is shown gesturing to an architectural drawing held by Henry Fox, Surveyor-General of the King's Works, and leaning informally on the back of a chair occupied by Charles Spencer, 3rd Duke of Marlborough, who had recently defected from the political grouping loyal to Frederick, Prince of Wales, and come over to the court party. Standing on the right, his left leg resting on a lawn-roller, is Thomas Winnington, a Lord of the Treasury, while at the table sits Henry Fox's brother Stephen, who – thanks to Hervey's influence – was created a baron soon after this picture was painted. The final figure depicted by Hogarth is a clergyman standing precariously on a chair that – possibly nudged backwards by Stephen Fox's cane – tilts towards the river flowing nearby. His telescope is trained on the church tower in the far distance. Horace Walpole, an important commentator on contemporary painting in this period, identified this rather comic figure as Dr John Theophilius Desaguliers, an influential Freemason and physicist. The six men are shown in a fictionalised parkland setting, complete with a statue of Minerva and dotted with the signs of luxurious ease and plenty – a punt lies waiting on the riverbank, a bottle and glasses stand on the table, and fruit spills across the table and over the edges of a generously laden basket lying on the ground.

This picture has attracted a great deal of speculation concerning its themes and narratives. Alistair Laing has suggested that Desaguliers's presence indicates a Masonic subtext to this gathering, and has noted that Stephen Fox and the Duke of Marlborough, as well as Hogarth himself, were Masons in this period.[18] On this reading – which is strengthened by the painting's explicit references to architecture, an art that Freemasonry regularly described as offering a model for ideal forms of social organisation – the Hervey conversation piece might seem to be celebrating a specifically Masonic form of fellowship. Other writers, including Jill Campbell and Ronald Paulson, have focused instead on the possible homoerotic dimensions of the work.[19] Hervey was well known in elite circles for his bisexuality and, while married with children, seems to have enjoyed a long-term sexual relationship with Stephen Fox. Such an association, as one might expect, attracted vitriolic condemnation, most famously from Alexander Pope, who had attacked Hervey in verse as a modern version of Nero's castrated lover Sporus.[20] Hogarth, in contrast, can be seen to have painted a work that, under the guise of a conventional conversation piece, commemorates the necessarily surreptitious relationship between Hervey and Stephen Fox, and the exclusive realms of masculine fellowship within which this relationship was allowed to flourish. In this respect it is interesting to note that a second version of the painting was owned by Stephen Fox himself.

While both interpretations carry weight, on their own they seem to tell only part of the story. What does seem clear, however, is that Hogarth's painting, through suggesting the range and intimacy of the relationships enjoyed between his subjects, actively celebrates Hervey's masculine coterie as one in which both political *and* personal interests successfully overlapped and entwined. We still, however, need to explain the rather incongruous figure of the toppling, non-aristocratic clergyman. Significantly, he seems not to fit very neatly into the group gathered around Hervey. Rather, he is the pictorial equivalent of the figure of Dr Smyth in *The Strode Family* (no.54) – someone, that is, who is partly an outsider and who, if he is to become fully integrated into the depicted coterie, needs to abandon his dangerously blinkered and isolated activity, return to the table and join the rest of the gentlemen in their confident, good-humoured and highly collaborative pursuit of personal pleasure and political power.

5
Street Life
Christine Riding

In the 1730s Hogarth developed an identity as a roving satirist who explores the city, exposing the folly and vice of its inhabitants while at the same time revelling in the chaotic vitality of its streets. In urban scenes, such as the first plate of *A Harlot's Progress* 1732 (no.43) or *The Enraged Musician* 1741 (no.72), Hogarth places the viewer in an intimate, if not claustrophobic, relationship with his or her surroundings. Thus London is presented as it might be encountered by someone walking in a crowd, rather than as a sanitised experience involving elegant and regulated thoroughfares, with Londoners as a spruced-up and well-behaved supporting cast. Hogarth's vision is bustling and dynamic, and sometimes grubby, confrontational and dangerous; the street is a truly 'public' space through which people meander and jostle. Nowhere is this better demonstrated than in *The Four Times of Day* 1736 (no.67), which takes us on a humorous walking tour through four distinct areas of the city: Covent Garden, Soho, Islington and Charing Cross.

Hogarth's images thus underline his first-hand knowledge of London's geography, neighbourhoods and communities and the texture of everyday urban life. In *Morning* (from *The Four Times of Day*), for example, Hogarth brings together both the 'polite' and the 'impolite' worlds of Covent Garden – the elegant square with the celebrated flower and vegetable market during the day, and the haunt of prostitutes, rakes and drunkards at night – by selecting the moment, early in the morning, when these worlds temporarily coexist. At the same time, however, these closely observed but distinctly unsentimental images also remind us that Hogarth, the roving satirist *and* gentleman artist, moves among the crowd, but is not necessarily of the crowd.

Hogarth's approach finds some important parallels with the writings of Edward 'Ned' Ward (1667–1731), which represent a brand of 'popular' journalism that developed in the late 1690s. Ward was a satirist, burlesque poet, political writer and some-time tavern owner who made a living by his pen. He might therefore be described as the archetypal 'Grub-Street hack', ever mindful of sale figures and grabbing the attention of the widest possible audience. Some of his most popular writings took the form of 'trips' around London and its environs, such as *A Walk to Islington* (1699) and *The Merry Travellers: or, A Trip upon Tentoes, from Moorfields to Bromley* (1721). The most influential was the monthly journal,

The London Spy (1698–1700), in which Ward proposed 'to expose the Vanities and Vices of the Town, as they shall by any Accident occur to my knowledge'.[1] The journal's success was due to its innovative formula, which presented London locations, entertainments, festivals and character types as they were witnessed and experienced by 'the spy', a newcomer to the city. Through his fresh eyes and insatiable curiosity, the familiar and the everyday become invigorated, newly fascinating and richer with satirical possibilities, as the spy wanders from taverns and coffee houses to fairs and parades, taking in the sights with an old school friend, who, like Hogarth, acts as a knowing guide.

In their representations of London's outdoor life both Hogarth and Ward concentrated more on the prosaic and the seamy than the official, the historic or the grand, which tended to be the focus of published travelogues, guides and graphic views of the city. The church of St Martin-in-the-Fields and St James's Palace, both significant architectural landmarks and symbols of church and state, are just part of the backdrop in *Beer Street* and Scene 4 of *A Rake's Progress* respectively (nos.98, 44). This also applies to public entertainments and spectacles. In *Industry and Idleness* Hogarth shows two crowd scenes: the Lord Mayor's procession through Cheapside and a public execution at Tyburn. In both cases the mayor and the criminal are but one, albeit important, detail in scenes that are teeming with keenly observed characters and incidents (see pp.188–9). Similarly, Ward's spy and his guide pay as much attention to the goings-on of the crowd as they do to the grand ceremonial of the Lord Mayor's parade passing by.[2] And it can be fairly stated that Hogarth, like Ward, also played to the bawdy and prurient instincts of his audience, while cataloguing urban life in all its variety. In *Morning* and *Noon* (*The Four Times of Day*) and *Beer Street*, market girls, maidservants and street sellers are fondled by drunken rakes, footmen and tradesmen; in *Strolling Actresses Dressing in a Barn* (no.69) a group of provocatively [un]dressed actresses, strut, posture and prepare for an evening performance; and in the final scene of *A Rake's Progress* some visitors to Bedlam hospital stroll among the insane, entertained by their bizarre antics (see p.93). Ward's spy, on a similar visit to Bedlam, even addresses some of the unfortunates, with comic results, but also wryly observes the prostitutes plying their trade with the other visitors. He concludes

The Four Times of Day
1736 (no.67, *Evening*, detail)

FIGURE 25

that the hospital is 'an Alms-House for Madmen, a Showing Room for Whores, a sure Market for Leachers, and a dry Walk for Loiterers'.[3]

Ward's target audience was the broader, literate middle classes, not scholars and cognoscenti. Hence his scatological observations, albeit interspersed with more learned references, smacked more of ground-level experience than revered literary prototypes. This earthy approach was underlined by such colourful comments as 'a Fig for St *Aug*[*us*]*tin* and his Doctrines, a Fart for *Virgil* and his Elegency, and a T[ur]d for *Descartes* and his Philosophy'.[4] Hogarth, as we know, could

be equally irreverent in tone. But his work habitually represented a complex interaction between high and low culture, which mirrored his own identity as both satirist and artist and indicated that his primary aim was the exclusive collectors' market. In this context works such as *The Four Times of Day*, *Strolling Actresses in a Barn* or *Southwark Fair* (no.65) correlate with the more elevated ambitions of Jonathan Swift's urban-themed poems, 'Description of the Morning' and 'Description of a City Shower' (both 1709), or John Gay's *Trivia; Or, The Art of Walking the Streets of London* (1716). In *Trivia* Gay makes ironic reference to classical works – Virgil's

celebrated *Georgics* (poems on rural life and farming) and Juvenal's third Satire, which describes the dangers of walking in the streets of ancient Rome – to create a satire in the form of a survival guide to the 'rough and tumble' of the city ('Through Winter Streets to steer your Course aright, | How to walk clean by Day, and safe at Night'[5]). Gay's allusions to classical literature and mythology ('Trivia', for example, not only means 'inconsequential details' but is also the Roman goddess of crossroads, witchcraft and the night) were aimed at an educated audience who would appreciate such ribaldries, just as they would enjoy Hogarth's ironic image in *Strolling Actresses*

FIGURE 26

FIGURE 25
Giovanni Antonio Canal
'Canaletto' (1697–1768)
*The Thames and the City of
London from Richmond
House* 1747
GOODWOOD HOUSE

FIGURE 26
Louis Philippe Boitard
(active 1734–1760)
*The Cov[en]t Garden
Morning Frolick* 1747
GUILDHALL LIBRARY,
CITY OF LONDON

Dressing in a Barn of an immodest street-player posing as Diana, the virginal goddess of the hunt, or, in *Southwark Fair*, the theatre troupe comically tumbling from their collapsing stage next to a sign that reads 'The Fall of Bajazet'.

Despite their varying literary ambitions, the common thread in the work of Ward, Swift and Gay is their evocative descriptions of the street as an overwhelming sensory experience. Thus Ward's spy exclaims:

My Ears were Serenaded on every side, with the Grave Musick [*sic*] of sundry *Passing Bells*, the rat[t]ling of Coaches, and the melancholly [*sic*] Ditties of Hot Bak'd *Wardens* and *Pippins* that had I had as many Eyes as *Argos* and as many Ears as *Fame*, they would have been all confounded, for nothing could I see but *Light*, and nothing hear but *Noise*.[6]

And similarly in *Trivia* Gay writes:

Now Industry awakes her busy Sons,
Full charg'd with News the breathless
 Hawker runs:
Shops open, Coaches roll, Carts shake
 the Ground,
And all the Streets with passing Cries
 resound.[7]

Hogarth's work constitutes a pictorial representation of such sights and sounds. Henry Fielding, for example, described *The Enraged Musician* as 'enough to make a man deaf to look at'.[8] The same could be said for

the crowd scenes of *Industry and Idleness*, *Southwark Fair*, *The Cockpit* (no.101) or *The March to Finchley* (no.113). Indeed, Hogarth's urban scenes are often characterised by noisy action and suspended animation: objects are dropped, coaches are overturned, structures collapse, guns are fired, drums are beaten, instruments are played, children cry and scream, and people cheer, shout, argue and fight, just as they would in real life.

Hogarth's representation of urban life is thus far removed from the order and sanity habitually evoked by perspective views of the city or the 'polite' genre-cum-topographical scenes of Balthasar Nebot, Joseph Nicholls and others, which were brought to a high point of sophistication and grandeur with the arrival of Antonio Canaletto in London in 1746 (see fig.25). In this context Hogarth's crowd scenes find greater parallels with graphic satires, for example, by Louis Philippe Boitard and Charles Mosley (fig.26). They also compare and significantly contrast with a popular genre of art known as 'Cries', which originated in Europe and first appeared in England in the late sixteenth century. These usually involved a series of single images of pedlars, such as milkmaids, chimney sweeps, and fruit- and fish-sellers, and the street cries associated with their trade or produce. Until the mid-eighteenth century this artistic genre was dominated in England by foreign artists. The most influential and sought-after series during Hogarth's lifetime was *The Cryes of the City*

of London by Marcellus Laroon, first published in 1687 (no.60). That these distinctive cries were a primary feature of London street life is underlined by the references made to them by Ward and Gay, in the quotations above, as well as Hogarth's energetic characterisations, which are clearly meant to evoke sound. Thus, unlike Laroon's hawkers, who are dislocated from the city and each other, Hogarth's pedlars wind through the street, actively competing with each other for attention, their faces contorted with the effort of yelling, singing or trumpeting, because, of course, their livelihoods depend on it. Perhaps this is why Hogarth's vision of London is so exhilarating – it lives and breathes.

58

Balthazar Nebot (active 1730–after 1765)
Covent Garden Market 1737
Oil on canvas
64.8 × 122.8
TATE. Purchased 1895

In the 1630s the Covent Garden area was redeveloped into an elegant, arcaded square with fashionable town houses that were inhabited by members of the aristocracy. By the 1730s, however, the residents were mainly artists, craftsmen and shopkeepers, and the location itself was at the heart of London's theatre world, as well as other entertainments and social venues such as taverns, coffee houses and brothels. Indeed, despite its smart reputation by day – augmented by the fruit and vegetable market, which was one of the sights of London – by night the piazza was from the early eighteenth century increasingly associated with vice and immorality. Hogarth lived in the Covent Garden area from about 1730 but moved to Leicester Fields (now Leicester Square) in 1733.

Probably of Spanish origin, Nebot was a painter of outdoor genre scenes and topographical landscapes. He seems to have been associated with a group of artists working in Covent Garden, including Pieter Angellis (see fig.28) and Joseph van Aken, all of whom painted scenes of everyday urban life. Here Nebot has combined genre with townscape painting, creating a panoramic image of the piazza and open-air market with a variety of people going about their daytime business. In the background can be seen St Paul's Church and the sundial column, which, with the arcade, were the piazza's characterising architectural features and thus were invariably included in the numerous perspective views produced by eighteenth-century printmakers. The composition on the left is dominated by the market stalls with fruit- and vegetable-sellers. On the right a pair of prize-fighters has attracted a crowd, and in the foreground a well-dressed couple taking a stroll pause as their child gives money to a beggar. Meanwhile, a dog urinates on a fence post. Such incidental details, common in Hogarth's work, suggest that the painting is an authentic record of London street life. However, unlike Hogarth's representation of Covent Garden in *Morning* (*The Four Times of Day*; no.67), the vantage point for the viewer is at a distance, resulting in physical and thus psychological detachment. In this context every Londoner, whether rich or poor, becomes a picturesque detail.

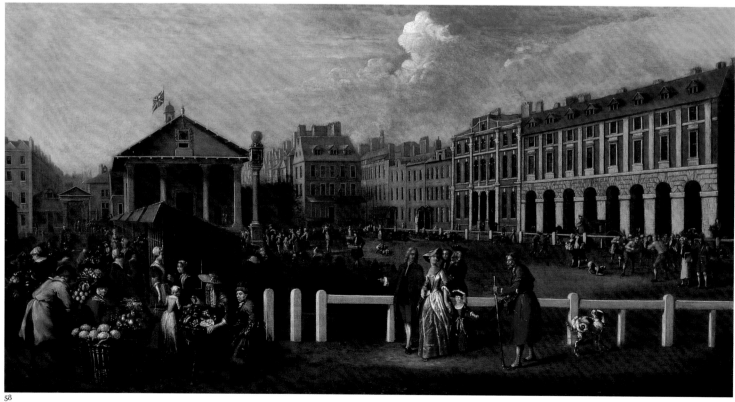

58

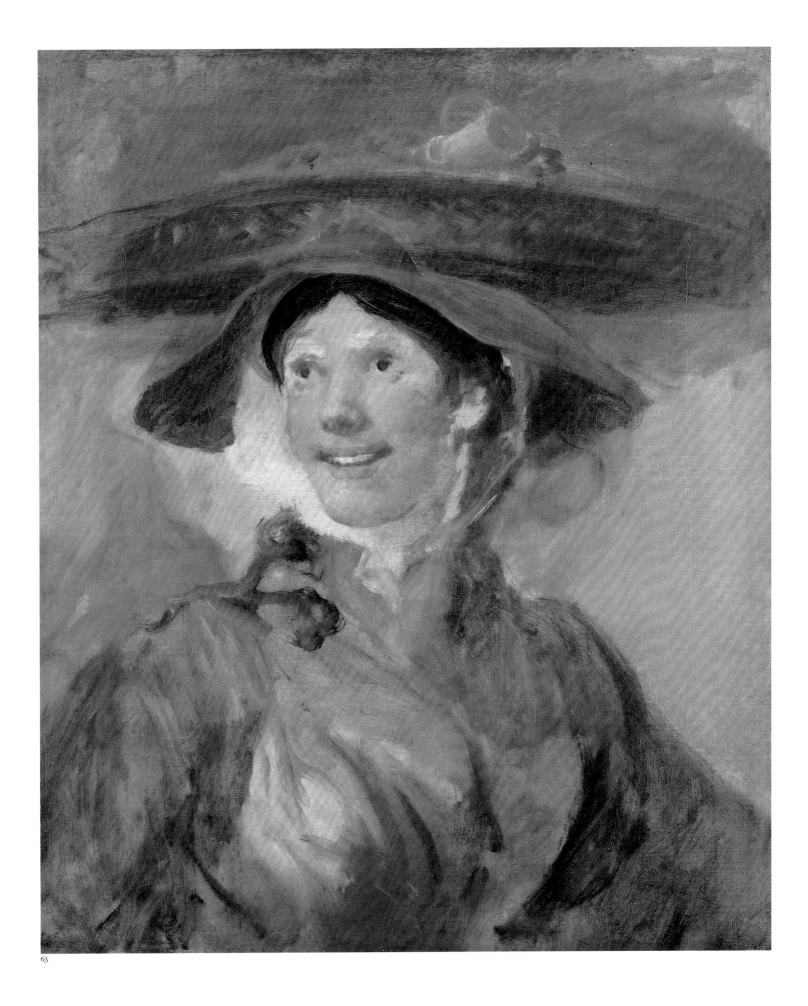

63

64

The Laughing Audience (or A Pleased Audience)
December 1733
Etching
18.8 × 17.1
ANDREW EDMUNDS, LONDON

As with a number of crowd scenes in this section, the theme of *The Laughing Audience* is that of everyday life being dramatised as a piece of theatre or entertainment. The print originally served as the subscription ticket for *A Rake's Progress* and *Southwark Fair* (nos.44, 65). The scene shows part of the interior of a theatre, compositionally divided into three sections. In the foreground sit three members of the orchestra. The audience members standing in the pit are laughing uproariously at the play being performed in front of them. Only one person appears not to be enjoying himself. Although contorted with laughter, each face denotes individuality and genuine enjoyment, underlining Hogarth's artistic pursuit of character rather than caricature.

In the background, standing in a theatre box, are two rakish aristocrats who are oblivious to the goings-on around them. One flirts with an orange-seller, while another orange-seller attempts to attract his attention from the pit. The other aristocrat, with studied elegance, 'gallantly' offers a lady a small box of snuff. Given that this print advertised *A Rake's Progress*, we might imagine that the theatrical performance that is causing so much unadulterated mirth among the lower levels of society is in fact the story of Tom Rakewell, whose ill-fated career as an aristocratic roué is ruthlessly satirised by Hogarth. In which case the 'gentlemen' at the back, who bear more than a passing resemblance to Tom in Scene 4 of *A Rake's Progress*, would be well advised to pay attention.

64

65

Southwark Fair (or *The Humours of a Fair*)
January 1733
Etching and engraving
36.2 × 47.3
ANDREW EDMUNDS, LONDON

66

William Dicey (active 1730s and 1740s)
The Humours and Diversions of Bartholomew Fair c.1735
Etching
45.5 × 56
MUSEUM OF LONDON

Southwark Fair was conceived as a kind of epilogue to *A Rake's Progress*, the final scene of which shows Tom Rakewell consigned to Bedlam (see no.44). He is surrounded by inmates who, lost to all reason, are acting out a variety of personas, including a saint, a king and a pope. As with the unseen players in *A Laughing Audience* (no.64), their collective performance is the cause of great amusement to members of the public, who have come to 'the madhouse' to be entertained. *Southwark Fair* transfers the viewer from a claustrophobic scene of delusion and insanity to a chaotic London street fair, with its theatrical troupes, street performers, puppet shows and carnival characters. At first glance, the images seem unrelated. However, the folk custom of fairs and street theatre closely relates to the role-playing and 'performance' seen in Bedlam, as elsewhere in *A Rake's Progress*, as well as reflecting Hogarth's own description of his pictorial narratives as 'dumb shows'.[12] The topsy-turvy world of the carnival, by its very nature, involved role play and role reversal, and the interchange between the elevated and the low, the wise and the foolish, the tragic and the farcical. It was also irreverent towards secular and ecclesiastical offices, rituals and institutions, and social pretensions, thus chiming with Hogarth's satirical agenda. Tom Rakewell's spectacular fall is comically paralleled (far left) by the troupe of players in costume tumbling downwards as their stage collapses. And the theme continues with the 'elevated subject matter' of the theatrical productions on offer at the fair (e.g. 'The Fall of Bajazet', 'The Siege [or Fall] of Troy' and the biblical fall of Adam and Eve).

Hogarth advertised this scene as 'A Fair' or 'The Humours of a Fair', only referring to it later in life as 'Southwark Fair'. As with *The Laughing Audience*, the theme is the interrelationship between theatre and everyday life. In this context the crowd milling around on the street are both spectators and part of the spectacle, as well as potential subject matter for Hogarth's satirical eye. The image also underlines that Hogarth's work could be at once allegorical and literal. This becomes obvious when comparing and contrasting *Southwark Fair* with the near contemporary print by William Dicey entitled *The Humours and Diversions of Bartholomew Fair* c.1735, which is a straightforward representation of an actual event. Southwark, on the south bank of the Thames, was long associated with London's theatre world (Shakespeare lived in Southwark for a time and his plays were performed at The Globe nearby). Southwark Fair was also called the 'Lady Fair', perhaps explaining the prominence of the drummer-girl in Hogarth's print. It was held in the area around the church of St George the Martyr, the square tower of which can be seen in the background. The composition also incorporates actual events, characters, theatre companies and the productions (mentioned above) that were performed at Southwark or elsewhere in London. On the right, for example, is a broadsword fighter seated on horseback, who has been identified as James Figgs, a well-known figure at the time. And the performer on a suspended rope (centre background) is thought to represent either Signor or Signora Violente. Rope dancers featured in London fairs from at least the seventeenth century. Laroon's expanded *Cries* of 1689 included a number of named street-theatre characters, such as 'Clark the English Posture Master' and 'Merry Andrew', but also two images of a rope dancer titled 'The famous Dutch Woman'.

67 EVENING

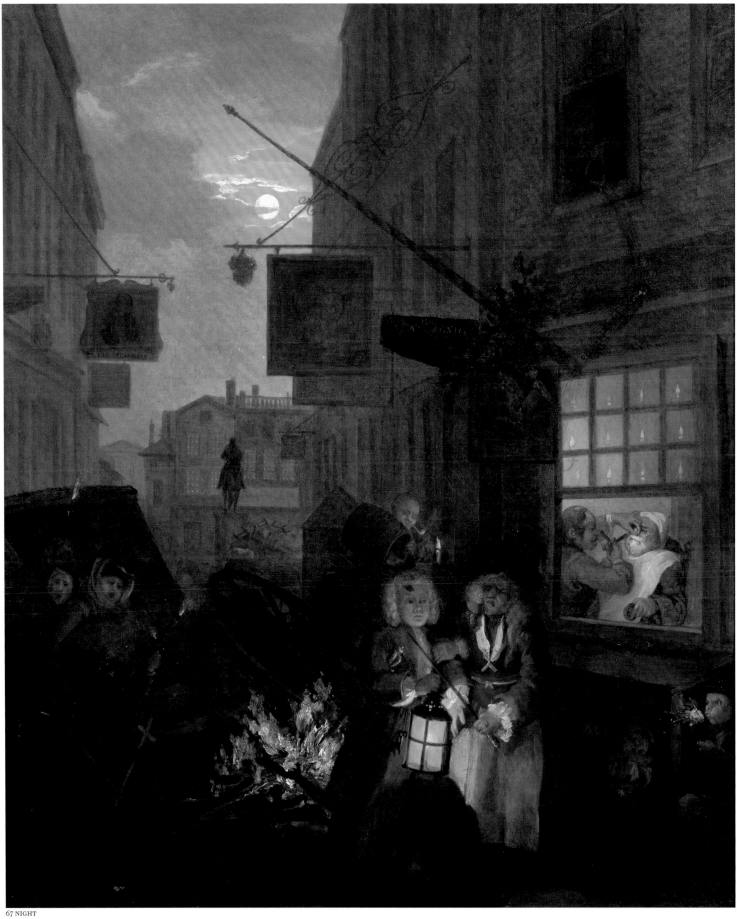

67 NIGHT

6
Marriage A-la-Mode

Christine Riding

Hogarth's *Marriage A-la-Mode* tells the story of a disastrous marriage of convenience between a profligate aristocrat's son and the daughter of an aspirant bourgeois. The sole purpose of the union is the exchange of wealth for social status. Without mutual affection, respect or companionship, the newly married couple conduct their emotionally empty lives pursuing an expensive, modish lifestyle and seeking sexual gratification with others. The tragic-comic plot concludes in a sensational, if not deliberately melodramatic fashion, with a murder, an execution and a suicide.

The title was taken from John Dryden's *Marriage à la Mode*, first performed in 1672 (see no.73). 'A-la-mode' means that something is merely of the fashion and not enduring. Thus the 'marriage *à la mode*' is, by definition, a travesty of marriage itself. On one level, then, Hogarth's acerbic analysis of the values and motivations of London's *beau monde* forms part of the ongoing debate on marriage and sexual ethics that thrived from the late seventeenth century. This was largely in response to the perceived promiscuity and immorality of contemporary society and manifested itself in a wide range of printed material including conduct books (the eighteenth-century equivalent of etiquette or self-help books), moral treatises, novels and pictorial satires. In 1727, for example, Daniel Defoe published his provocatively titled *Conjugal Lewdness; or, Matrimonial Whoredom*. While the focus was impermissible behaviour (predominantly sexual) within marriage, Defoe's treatise – in tandem with numerous contemporary commentaries – set out arguments against various forms of 'unsuitable' marriages, such as marrying without love and respect or for material considerations, marriages between people of unequal ages or social status, or marriages to satisfy family. Hogarth deftly combined all these 'unsuitable' circumstances, bar the age factor, into the marriage between Lord Squanderfield and the alderman's daughter.

In keeping with the anti-luxury discourse of the early eighteenth century, Defoe also argued that the spread of sexual excess correlated with increased wealth and consumption, leading to disease and physical decay. 'Our Luxury', he noted, 'is encreased; and with our Luxury, our Vices, and other Extravagances, our Lasciviousness, Sensuality, and, in a Word, our Impudence, and with all these our Distempers.'[1] A similar correlation is made throughout *Marriage A-la-Mode*. The

marriage itself is brokered in a luxurious high-society setting with the elderly aristocrat and his effete son portrayed as vain, self-indulgent and ailing with gout and venereal disease respectively. The effects of cultural, social and physical corruption are carried forward in the narrative primarily through Lord Squanderfield's increasingly enfeebled, contaminated, yet resplendently attired body, and finally to his sickly infant child. In this context the most shocking of all the episodes is Scene 3, when Squanderfield visits a surgery. He is seen protesting about the ineffectiveness of mercury pills (then touted as a cure for syphilis) prescribed by the quack doctor. Everyone in the room is infected with the disease, including a very young girl who appears to be the aristocrat's mistress. As previously underlined in *A Harlot's Progress* (no.43), prostitution and the spread of disease were perceived as synonymous in eighteenth-century society. While contemporary commentaries largely assigned blame to the female prostitute for trading her body for money (rather than her clients who voluntarily paid for the 'service'), such a responsibility could hardly be imposed on someone who is barely more than a child. Thus we are left to marvel at the perverse depths to which Squanderfield's self-gratification has sunk.

If the aristocrats in *Marriage A-la-Mode* are presented as hopeless dissolutes, the members of the middle classes do not fair any better. The thrifty alderman, dazzled by rank, sells his daughter into the Squanderfield family in the anticipation of her becoming a countess. The daughter is initially distraught at the prospect of this marriage but speedily abandons herself to the 'pleasures' of high life and follows her husband's lead in squandering money and conducting extramarital liaisons. Hogarth had previously satirised 'the aspirant bourgeois' who embarks on a dissipated life in *A Rake's Progress*, which also included a marriage of convenience (see no.44). But Hogarth's plot involving the marriage of a rakish aristocrat to someone lower-born would have had particular resonance in the wake of Samuel Richardson's *Pamela; or, Virtue Rewarded*, a literary phenomenon that was praised and vilified, pirated and parodied from the moment it first appeared in 1740. The interconnected themes of the novel are marriage, love, virtue and class identity, with the heroine, an educated lady's maid who resists the sexual advances of, and finally reforms and marries, her aristocratic master. Importantly,

Marriage A-la-Mode: 6 The Lady's Death 1743–5 (no.77, detail)

Richardson began writing *Pamela* as a conduct book. And his subsequent revisions to the novel included adapting Pamela's speech to resemble a more overtly 'middle-class' figure – in contrast to the character's low-born origins – thus making her marriage to a nobleman significantly less scandalous. It also reinforced the particular appeal of Pamela to a bourgeois audience, in that the character's industry, moral virtue and sexual restraint chimed with the self-identity of the middle classes who were consolidating their power and challenging the aristocracy's social and cultural pre-eminence. At the same time Pamela's innate 'nobility' is an attribute that the 'real-life' aristocrat, Mr B., blatantly fails to live up to, until, of course, his own character transforms for the better under Pamela's influence. Hence, after an unpromising start, their relationship develops into one of mutual affection, fidelity and companionship, i.e. the model marriage by contemporary middle-class standards.

That *Marriage A-la-Mode* was, in part, a jibe at Richardson's novel is underlined by the final scene entitled *The Lady's Death*. Here Hogarth parodies an illustration by the London-based French artist, Hubert-François Gravelot, from an edition of *Pamela* published in 1742, which shows the heroine turning to receive her baby from the family nurse (no.79). The loving mother/child vignette is reworked by Hogarth to show a distraught nurse proffering a sickly infant towards the distinctly un-maternal countess, who has just expired. This skit on another artist's work also reminds us that the satirical thrust of *Marriage A-la-Mode* was as much about patronage, aesthetics and taste as it was about marriage and morals. The series is, in fact, an unremitting attack on the absorption by the social elite of foreign and in particular French luxury goods, cultural values and lifestyle. Over and above the title itself, *Marriage A-la-Mode* includes Italian and Dutch Old Masters, French portraiture and furnishings, oriental decorative arts, an Italian castrato singer and a French dancing master, a turbaned black pageboy, a masquerade reference and a bagnio. Just as the parvenu Tom Rakewell had conducted a levée in *A Rake's Progress*, so the alderman's daughter adopts the aristocratic *toilette*. Both are rituals associated with the French court. And even syphilis, which Lord Squanderfield probably contracts abroad, was popularly known as 'the French pox'. Thus his emasculated and diseased body is

additionally emblematic of the spread of 'foreign' culture that has infected and weakened British identity, society and commerce. Hogarth's concerns were, in fact, widely held. The Anti-Gallican League, for example, was founded in the same year that the prints of *Marriage A-la-Mode* were published, with the explicit aim of extending 'the commerce of England', discouraging 'the introduction of French modes' and opposing 'the importation of French commodities'.[2] And high society's appropriation of French culture struck many as perverse, given that Franco-British political relations were often strained, if not openly hostile. In 1745 British forces were defeated by the French at the Battle of Fontenoy and immediately recalled to counter a French-backed Jacobite rebellion with an invading army marching southwards towards London (see no.73).

Hogarth's references to foreign culture were thus topical and multifaceted. The Italian Old Masters in Scenes 1 and 4, for example, signalled the British aristocracy's continuing predilection for such paintings by foreign artists, to the detriment of native talent. But they also drive the narrative forward and establish a visual correlation between the sophisticated programme of symbols, allusions and gestures employed in Hogarth's modern moral subjects and that in history painting, then appreciated as the most intellectually and artistically rigorous of all the painting genres. In this context it is worth noting Hogarth's concurrent ambitions as a history painter and, in particular, the episode in the mid-1730s when he prevented the appointment of the Italian artist Giacomo Amiconi at St Bartholomew's Hospital by offering his services free of charge (see p.125).

It must also be remembered that *Marriage A-la-Mode*, whether in painted or engraved form, was conceived and executed as a sophisticated, luxury commodity, equal, if not superior, to any of the *objets d'art* so meticulously represented within each scene. Hogarth claimed that he travelled to Paris in 1743 for the express purpose of finding the best engravers for his *Marriage A-la-Mode* paintings, the formal qualities and palette of which corresponded to, and sometimes deliberately evoked, French contemporary art and Rococo design, which originated in Paris. What Hogarth saw during his visit is not known. That French art informed the style and composition of *Marriage A-la-Mode*, however, is beyond doubt. The final scene, for example, includes a still life of a table

covered in white cloth and laid with food and utensils, which is reminiscent of the work of Jean-Baptiste-Siméon Chardin (1699–1779), in particular *The White Tablecloth* of 1731–2 (fig.32). But such 'quotations' do not simply demonstrate Hogarth's tremendous technical facility and familiarity with cutting-edge European art; they enrich the satirical content. In Jean-François de Troy's *The Declaration of Love* (no.76) the harmonious palette and skilfully rendered figures, costumes and furnishings are of an elevated artistic quality that corresponds (visually at least) with the 'people of quality' seated on the sofa. Leaning languorously on a silk cushion, the lady listens to her admirer's elegant protestations of love, the erotic subtext intimated by the mythological scene of seduction hanging behind their heads. In Scene 1 of *Marriage A-la-Mode* Squanderfield and his fiancée, seated on a sofa, are dressed in similar fashions to the aristocrats in de Troy's painting (note the identical black bow of his purse wig, knotted at the cravat, and her loosely fitted dress with sack-back and small lace cap trimmed with flowers). But instead of a scene of gallantry and courtship, they are turned from each other, the aristocrat besotted only by his reflection in the mirror, the parvenue inelegantly slumped forward, the misery on her face amplified by the image above of a screaming Medusa. Thus Hogarth at once emulates and subverts de Troy's art and at the same time underlines the richness of his own.

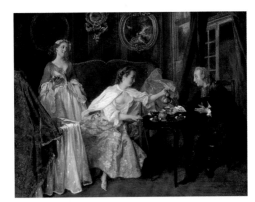

symptom. Given the close proximity between the girl and the viscount and the fact that he is seated while she stands, we can assume that she is a low-born prostitute currently in his pay. Her overskirt and the older woman's sleeve are made from the same fabric. It is therefore probable that they are connected, perhaps procuress and prostitute and/or mother and daughter. Thus the woman's anger and the child's action may, in fact, be a well-rehearsed ruse to lay blame on the viscount for transmitting the disease and to extort money from him.

Scene 4: *The Toilette*

Like other members of London's fashionable elite, the alderman's daughter has adopted the *toilette*, an urban custom established by the French court of receiving visitors in the bedroom or boudoir while the aristocrat dressed. It was used as a subject in French art, habitually showing a lady

dressing, such as in Nicolas Lancret's *Morning* 1739 (fig.31), which Hogarth may have known through an engraving of 1741.

The display of coronets on the bed and dressing mirror in *The Toilette* suggest that the old earl has died and the alderman's daughter has been elevated to the position of countess. Like the newly rich Tom Rakewell, she is surrounded by hangers-on (see Scene 2 of *A Rake's Progress*, no.44). These include an Italian castrato singing, accompanied by a flautist, an effeminate French dancing master sipping chocolate and a gentlewoman swooning in exaggerated rapture over the music, the absurdity of which is amplified by the servant's amused expression as he offers her a drink. Meanwhile, a French hairdresser is curling the countess's hair (note she is wearing a white powdering mantle to protect her sumptuous silk dress). She leans on the back of her chair, from which hangs a rope of coral, used by

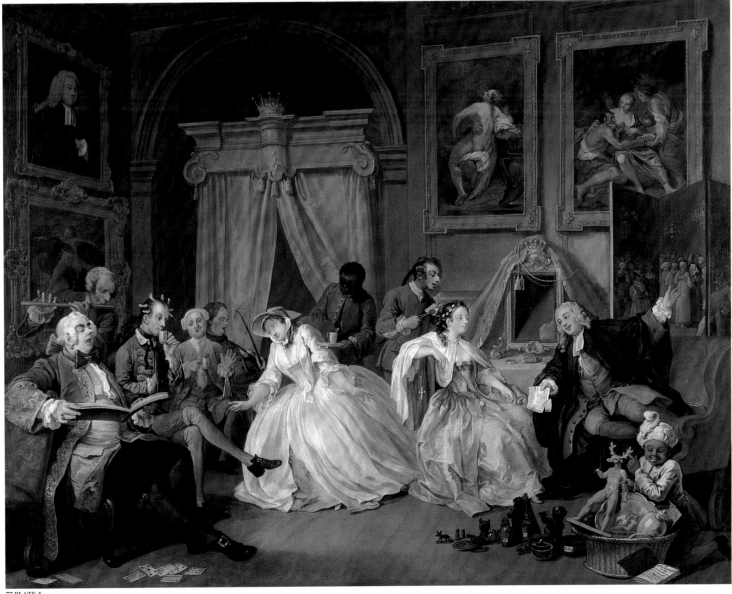

teething children. Her child, however, is nowhere to be seen, suggesting a lack of maternal interest on the part of the countess. The lawyer Silvertongue has reappeared, lounging on a sofa. Clearly at ease in the countess's bedroom, he holds a ticket in one hand and points to a screen showing a masquerade ball with the other. The Old Master paintings above their heads, showing mythological and biblical seduction scenes (Correggio's *Jupiter and Io* and *Lot and his Daughters*), and similarly the tray in the basket (right foreground), showing Leda and the Swan, underscore the fact that the countess and Silvertongue are having an affair. Indeed, his portrait is prominently displayed on the far left. The exotically dressed child-servant has pulled out a figure of Actaeon from the basket and points at the horns, a reference to the new earl as a cuckolded husband. In classical mythology Actaeon surprises Diana, the goddess of hunting, while she bathes in

secret. His punishment is to be transformed into a stag and killed by Diana's pack of dogs. Hogarth's allusion to this myth presages the next scene of *Marriage A-la-Mode* set in a bagnio (originally meaning a public bathhouse in Italy or Turkey), where the earl discovers the adulterous couple in bed and dies following a sword fight with Silvertongue.

Secrecy, disguise and seduction are the themes of *The Toilette*. The ritual itself was imbued with sexual connotations in French art and literature, as, for example, in François Boucher's *Lady Fastening her Garter (La Toilette)* 1742 (fig.33, p.155), or in the novels of Crébillon *fils* and Prévost's *Manon Lescaut* (1731), in which the *toilette* was established as a principle literary motif. Silvertongue arranges an assignation with the countess at a masked ball, where disguise aided and abetted illicit encounters. On the cushion beside Silvertongue is an edition of the erotic novel

Le Sopha (The Sofa) by Crébillon *fils*, first published in Paris in 1742 and available in English the same year. The story is set in the Orient, thus underlining both the vogue for licentious French literature and the exotic frisson of the East as represented by the Orient-inspired sofa and the turbaned black servant. Interestingly, the plot of *Le Sopha* revolves around a man who by magic has been turned into a piece of furniture. Thus concealed, he voyeuristically observes the unwary 'Arabian' women and their gallants and even provides a stage for their lovemaking.

Scene 5: *The Bagnio*
In England the original meaning for a bagnio was a coffee house that provided Turkish baths. By the time that Hogarth painted *Marriage A-la-Mode*, the word had additional significance as a place where rooms could be hired without questions and where prostitutes could be made available.

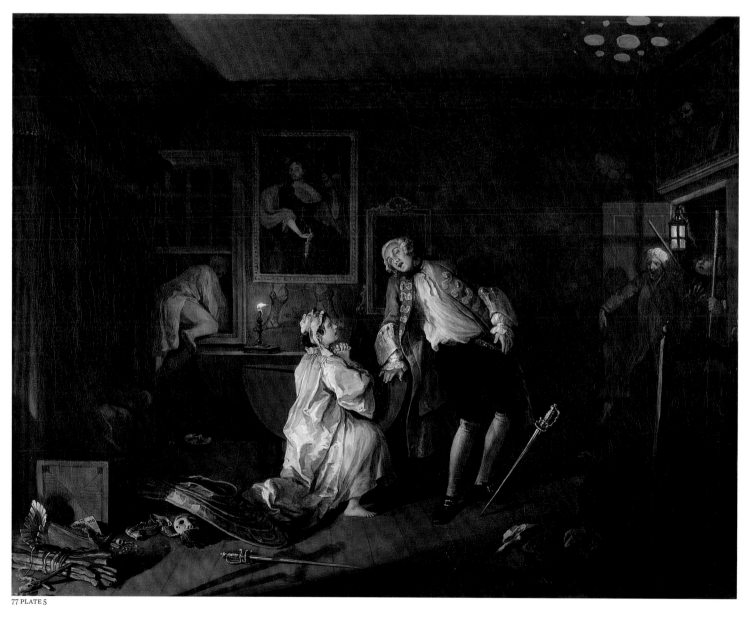

77 PLATE 5

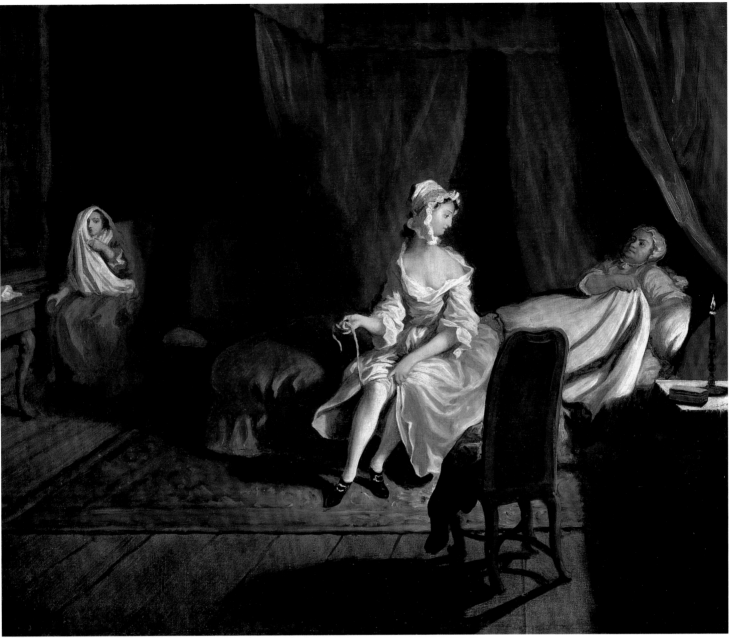

82 VII

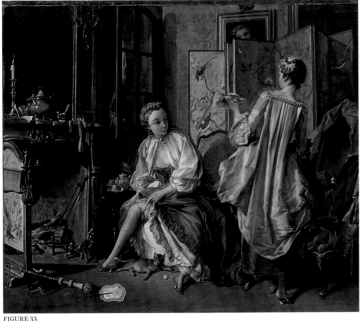

FIGURE 33

FIGURE 33
François Boucher
(1703–1770)
Lady Fastening her Garter
(*La Toilette*) 1742
MUSEU THYSSEN-
BORNEMISZA, MADRID

83

Piquet: or Virtue in Danger (The Lady's Last Stake) 1759
Oil on canvas
91.4 × 105.4
ALBRIGHT-KNOX ART GALLERY, BUFFALO, NEW YORK. GIFT OF SEYMOUR H. KNOX, JR., 1945

In 1758 the Irish peer James Caulfield, 1st Earl of Charlemont, persuaded Hogarth to paint one last satirical painting by offering him remarkably generous terms: he would allow the artist to choose his own subject and to name his own price. The resultant, luxuriously painted canvas returns to the territory of aristocratic vice and sexual subterfuge that the artist had explored in *Marriage A-la-Mode* – indeed, this painting's setting and narratives offer a suggestive pictorial echo of the second image of that series.

Hogarth's painting draws on a famous theatrical comedy, Colley Cibber's *The Lady's Last Stake* (1708), and depicts a married aristocratic woman who, addicted to gambling, has just lost her fortune to a glamorous young army officer. The cards have been despairingly thrown on the floor and onto the fire, while the woman's jewels, trinkets and banknotes are piled high in the soldier's hat. Hogarth pictures the officer as he offers his victim the chance to regain her fortune. The soldier's terms, according to Cibber's play, are as follows: the two will play one more game, and if she wins, she will regain her fortune, and have no obligation to him; if she loses, however, she will still have her goods returned but be obliged to take him as her lover. In the artist's own words his female protagonist is shown 'wavering at his suit whether she should part with her honour or no to regain the loss which was offered to her'.[11]

Hogarth's heroine is someone who can either be interpreted as a virtuous woman clinging desperately onto her respectability – and this is the reading suggested by the artist's theatrical source – or, more insidiously, as someone who is highly aware of her own erotic appeal and who, under the guise of coyness, is excited by the soldier's offer. Her body language is left decidedly ambiguous: is her glance outwards at the viewer vulnerable or flirtatious? Are her blushing cheeks a signal of shame or of dawning desire? Is her gesture of reaching across to the fireguard a sign of her determination to protect herself from the flames of lust, or rather of her wish to extend another graceful, exposed forearm and hand in front of her fellow-gambler's eyes? Hogarth leaves such questions unanswered, while filling the environment with a series of symbolically resonant but ambiguously juxtaposed objects: in the words of Mary Webster, while 'the clock with its motto NUNC N.U.N.C. invites her to profit from love and the moment, the penitent Magdalen of the picture warns of her future repentance if she surrenders'.[12] One last clue seems to suggest the way events are likely to unfold: a letter from the woman's husband lies forlornly in the corner, abandoned like the cards that lie on the hearth nearby. MH

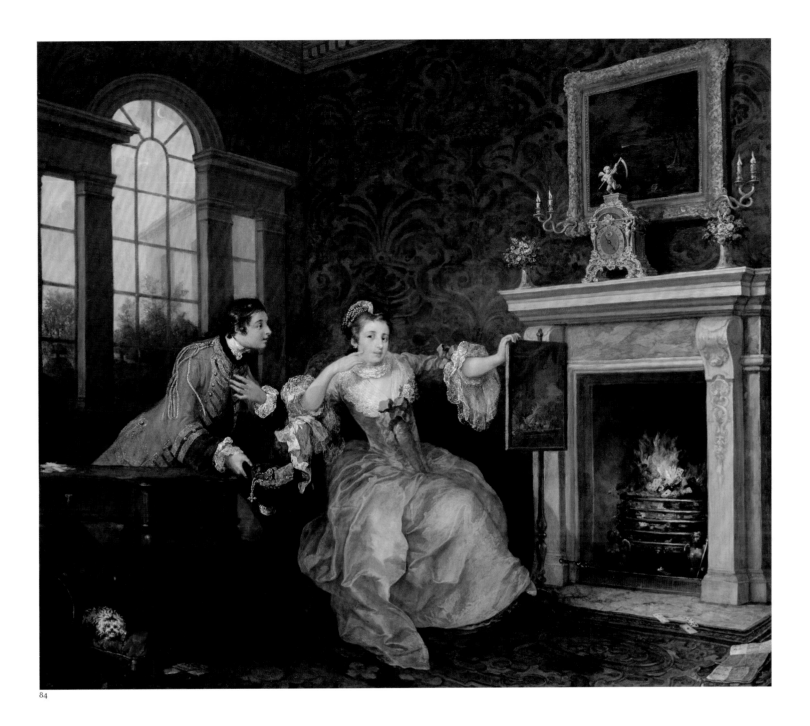

84

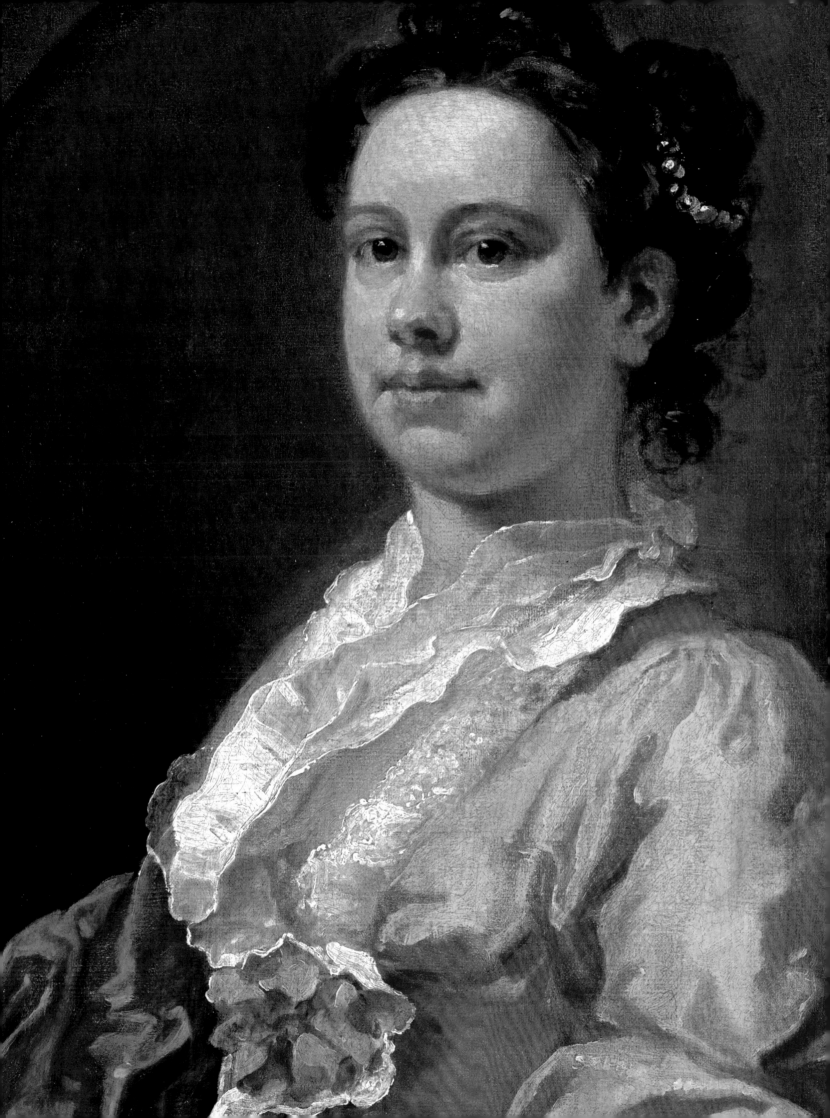

7

The English Face: Hogarth's Portraiture

Mark Hallett

Writing his unpublished 'Autobiographical Notes' towards the end of his life, Hogarth reflected with both pride and bitterness on his career as a portraitist. At one point in this text he notes that his monumental portrait of Captain Coram at the Foundling Hospital (no.84) had stood 'the test of twenty years as the best portrait in the place notwithstanding all the first portrait painters in the kingdom had exerted their talents to vie with it'.[1] Elsewhere, however, he jots down that his 'attempting portrait painting' had brought him more abuse than any other of his artistic activities.[2] He sums up by declaring that his portraits 'met with the like approbation Rembrandt's did, they were said at the same time by some [to be] Nature itself by others exicrable [*sic*]'.[3]

The career in portraiture that generated such ambivalent reflection began in earnest with the picture of Coram, which was installed at the Foundling Hospital in 1740. With this painting Hogarth had hoped to establish himself at one stroke as a leading practitioner of the genre and as a worthy successor not so much to Rembrandt as to the most celebrated portraitist ever to have settled in Great Britain, the seventeenth-century painter Sir Anthony Van Dyck. In his 'Autobiographical Notes' Hogarth remembers that 'one day at the academy in St Martin's Lane I put this question, if any at this time was to paint a portrait as well as Van Dyck would it be seen and the person enjoy the benefit? They knew I had said I believed I could.'[4] The portrait of Coram, according to Hogarth, was painted to test this point, and inaugurated a series of ambitious portraits that took up much of the artist's energies in the early 1740s.

In launching himself as a portraitist, Hogarth entered an artistic sphere rife with rivalries and jealousies. The artist later remembered that 'the whole nest of Phizmongers [portraitists] were upon my back every one of whom has his friends, and all were turn[ed] to run them down – my women harlot[s] and my men charicatures'.[5] The acidic response with which Hogarth's works were met was partly the consequence of the fact that the market for portraiture was exceptionally competitive. In the words of the commentator Jean André Rouquet writing in 1755, 'portraiture is the kind of painting the most encouraged, and consequently the most followed in England'.[6] Rouquet notes the ways in which portraiture had been turned into a slick, highly efficient form of artistic manufacture, involving speedy execution, extensive use of studio aids like

the 'lay-man' (a wooden dummy that could be arranged into a variety of poses), the parcelling out of drapery painting to specialists and the furnishing of elegant studio spaces in which to entertain clients. He goes on to discuss two of the most prominent practitioners of the genre, Allan Ramsay and Jean-Baptiste Van Loo, who had settled in London in 1738 after having honed their skills on the continent. Rouquet commends the Scottish-born Ramsay for having 'brought a rational taste of resemblance with him from Italy', while his discussion of Van Loo concentrates on the spectacular success he enjoyed on his arrival from Paris, which 'was flattering to a very high degree. Scarce had he finished the pictures of two of his friends, when all London wanted to see them, and to have theirs drawn ... Crowds of coaches flock'd to Mr Vanloo's door, for several weeks after his arrival, just as they crowd the playhouse.'[7]

Hogarth, as we might expect, seems to have been stung into action by the artistic eminence and financial rewards enjoyed by these two newcomers to the London art world. Indeed, it was Van Loo's rise to fashion that prompted Hogarth's claim to paint portraits as well as Van Dyck, and Ramsay to whom – among other artists at the St Martin's Lane Academy – he had made this boast. But in preparing to enter the crowded market for portraiture and compete with such men, and with prominent English artists like Thomas Hudson and Joseph Highmore, Hogarth was faced not only with stiff competition: he was also confronted with the challenge of adapting to the specific demands of portraiture as an artistic genre. Most obviously, portraiture is about capturing an individual's likeness, something that he later declared required a level of 'constant practice' that he had never been able to enjoy.[8] Dauntingly, however, achieving an accurate likeness was only one aspect of ambitious portraiture: in the words of Jonathan Richardson, the most sophisticated commentator on this branch of art in the early eighteenth century, 'a portrait-painter must understand mankind, and enter into their characters, and express their minds as well as their faces'.[9] Finally, portraiture was in many ways a more stringent, conservative and confined form of image-making than the other artistic categories – graphic satire, history painting, the conversation piece – in which Hogarth specialised. Richardson usefully contrasted it to history painting in this respect:

Mrs Salter 1741 or 1744
(no.89, detail)

A History-Painter has vast liberties; if he is to give life, and greatness, and grace to his figures, and the airs of his heads, he may chuse [sic] what faces, and figures he pleases; but the [portrait painter] must give all that (in some degree at least) to subjects where it is not always to be found; and must find, or make variety in much narrower bounds than the History-Painter has to range in.[10]

For Hogarth, then, the challenge was, firstly, to fabricate works that communicated the likeness, temperament, calling and histories of his sitters; and secondly, to translate the invention, variety and narrative flair for which he was already famous into the relatively 'narrow bounds' of paintings that typically featured only one or a few figures.

Hogarth responded to the commercial and aesthetic circumstances in which he found himself by cultivating a clientele and a mode of portraiture that distinguished itself from that of his competitors in a number of ways. First of all, the great majority of Hogarth's patrons for portraits were drawn not from the fashionable, metropolitan, aristocratic society courted by artists like Van Loo and Hudson, but from communities who defined themselves in relation to different forms of status and value. In particular, many of Hogarth's subjects were members of the mercantile, professional, ecclesiastical and scientific spheres; many, too, were linked by their shared involvement in such philanthropic enterprises as the Foundling Hospital. This stream of patronage was a consequence not only of Hogarth's prickliness when dealing with more socially elevated patrons but also of the particular kind of portrait he painted. For Hogarth specialised in producing images that, rather than stressing cosmopolitan sophistication or aristocratic languor, promoted other kinds of virtues: directness, benevolence, energy and lack of pretension for his male subjects; and modesty, ease, sincerity and polite restraint for his female sitters. His subjects do not project a haughty, self-conscious sense of privilege but are typically rendered as if accessible, benevolent and aware of our presence – as polite men and women without any great 'airs'.

These qualities are reinforced by the relative absence of flattering effect or pictorial flashiness in Hogarth's portraits – hence the opprobrium they sometimes received as mere 'charicatures'. The faces of his men and women are typically illuminated by a lucid and unadulterated light, and Hogarth tended to record, rather than refine, those features – a wide nose, for instance, or a corpulent chin or a mole – that did not correspond precisely to a fashionable facial model. Similarly, the bodies of his sitters – particularly those of his squat, solidly built male subjects – consistently refuse to conform to the elongated bodily ideal prized in more elite circles. Finally, and with the exception of his grandest ecclesiastical portraits, the dress and settings in which he enveloped his subjects are rarely elaborate or ostentatious. For both artist and sitters, it seems, this form of pictorial plain-speaking suggested a welcome lack of affectation and vanity. At the same time Hogarth ensured that this modesty did not extend to an unwelcome, puritanical extreme: his portraits – particularly those of his female sitters – typically grant their subjects an understated good taste, and are also characterised by subtle forms of painterly display that confirm both the artist and his sitter's refinement.

If these kinds of pictorial characteristics seemed to chime with the values of the 'middling' community for which he catered, it can also be suggested that Hogarth saw those same characteristics as expressive of national virtues. Significantly, the artist signed a portrait he executed in 1741 with the words 'W. Hogarth Anglus pinxit'.[11] His explicit identification with Englishness can be understood as a marker of artistic defiance, whereby Hogarth distinguishes himself from the foreign-born artists who had long dominated the field of portraiture. At the same time, this nationalistic tag gestures to the 'Englishness' of the portraiture that Hogarth produced and of the people whom he pictured. These men and women – individuals such as the philanthropist Thomas Coram, the cleric Bishop Benjamin Hoadly, the actress Lavinia Fenton and the merchant George Arnold – embody those supposedly 'English' virtues of sobriety, energy, directness and sincerity that, in a period of European conflict and growing anxieties about the impact of French culture on English society, were being emphasised as a counterweight to the excessive refinement associated with the French and with an aristocratic class in thrall to Parisian fashions. It is no coincidence that Hogarth produced the great majority of such 'English' portraits in the same decade in which he executed his scathing satiric attack on the impact of foreign mores,

Marriage A-la-Mode (no.77).

Hogarth's portraiture was also driven by a range of other, more local concerns to do with the artistic traditions and possibilities of portraiture as a genre. Thus in his portraits of Coram, Hoadly and Thomas Herring (nos.84, 91, 92) the artist not only expresses a certain set of cultural values but explores the narrative, symbolic, compositional and painterly potential of the full-length and episcopal portrait, while in his great depictions of filial devotion and interaction, the paintings of the Graham and Mackinen children (nos.93, 94), Hogarth pushes modern British portraiture to new degrees of iconographic, narrative and emotional complexity. In his portraiture, no less than in any other sphere of his art, Hogarth was regularly testing, changing, adapting and inventing. Just like so many of the dynamic individuals he loved to paint, he was never standing still.

Thomas Herring,
Archbishop of Canterbury
1744–7 (no.92, detail)

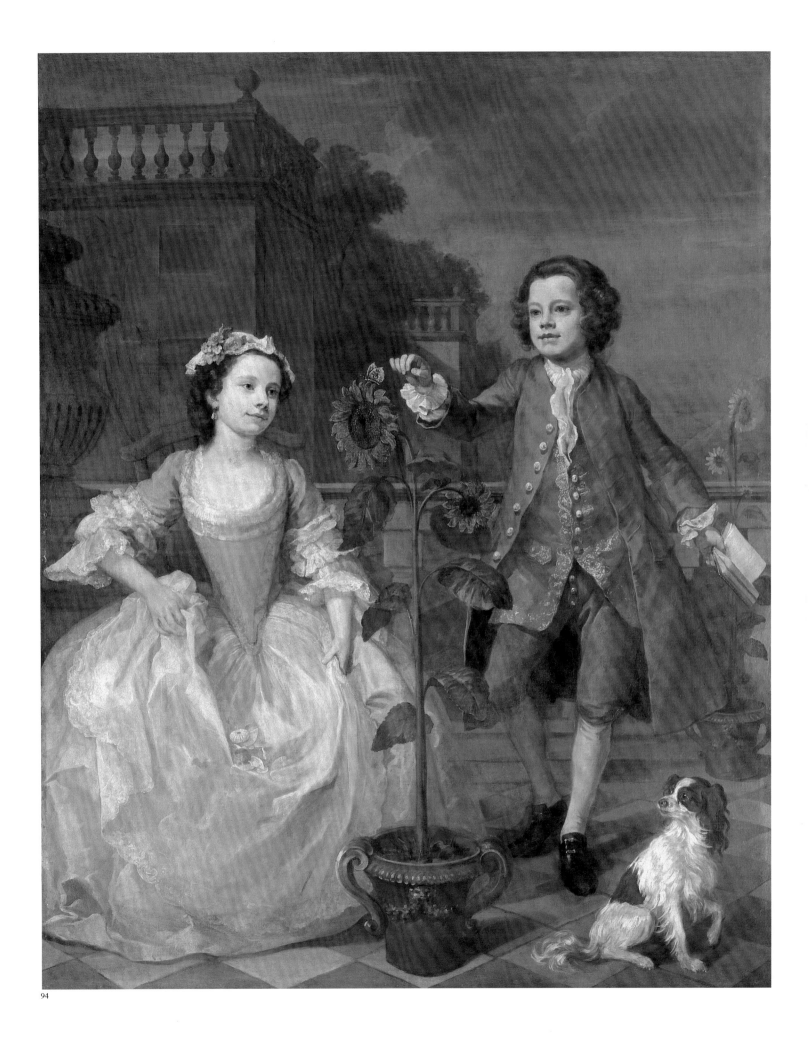

94

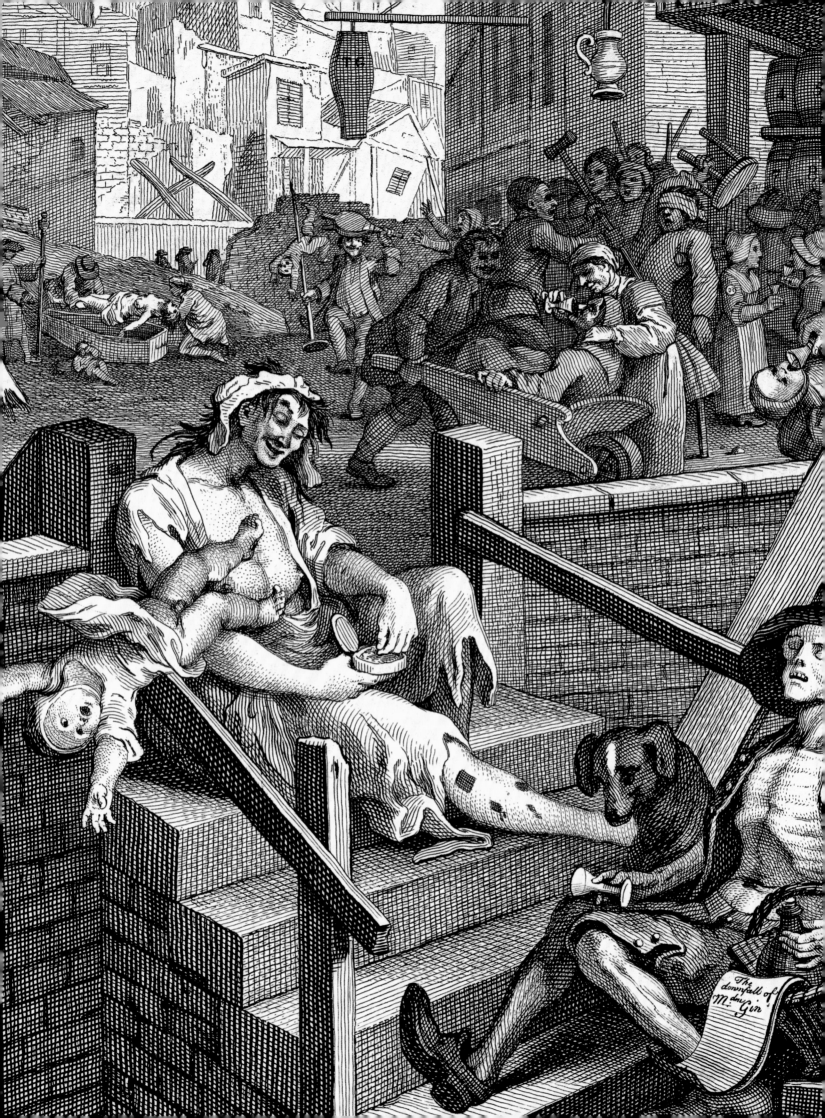

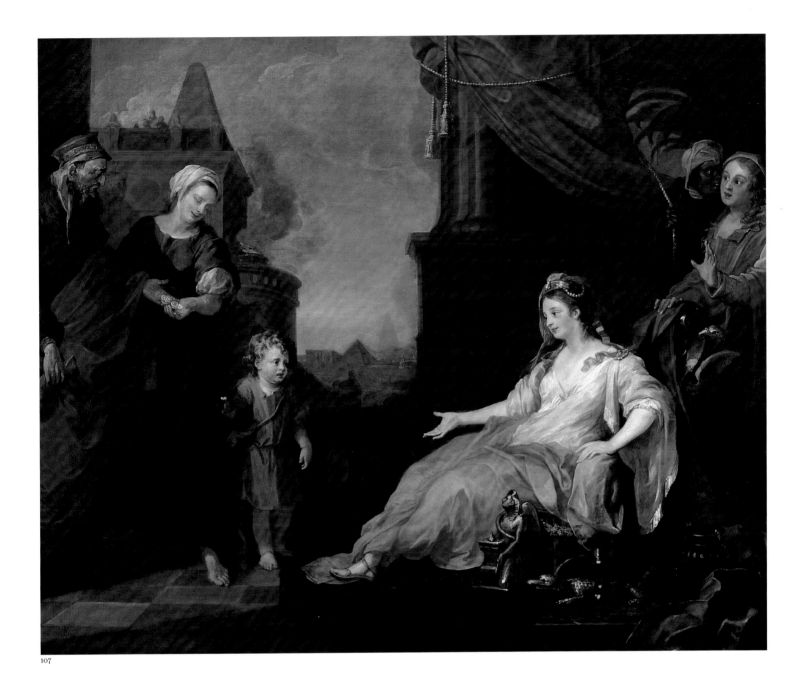

107

108

Paul before Felix (second state)
5 February 1752
Etching and engraving
42.2 × 52.4
ANDREW EDMUNDS, LONDON

109

Luke Sullivan (1705–1771) after
William Hogarth
Paul before Felix (second state)
5 February 1752
Etching and engraving
36.1 × 47.3
ANDREW EDMUNDS, LONDON

110

Paul before Felix [Burlesqued] (fourth state)
1 May 1751
Etching and engraving
25.4 × 34.3
ANDREW EDMUNDS, LONDON

This trio of prints, based on the enormous painting of the same name (fig.39), usefully illustrates Hogarth's continual changes of mind regarding the images he produced, and his sensitivity to perceived or anticipated criticism. They also record and respond to one of the artist's most prestigious and public commissions. Hogarth painted *Paul before Felix* for the lawyers of Lincoln's Inn, and the picture continues to hang in the great hall at Lincoln's Inn Fields. Given the source of his patronage, it is not surprising to find that Hogarth decided to represent a biblical scene set in a packed courtroom.

Hogarth's painting and engraving depict the New Testament figure of St Paul pleading his and Christianity's case before the tyrannical Roman governor of Caesarea, Felix (Acts 24). Paul had been brought to trial for ignoring Jewish laws, and the Roman advocate Tertullus has just finished speaking on behalf of the Jewish elders. The lawyer leans on his lectern as the Christian saint, pictured with chained, gesticulating hands, replies to the court. Before him sit in judgement not only Felix, shown wearing a laurel wreath on his head, but also – in the painting and in Hogarth's initial engraving (no.108) – the seductive figure of his wife Drusilla, a Jewish woman who had married Felix while still wed to her first husband. An elderly judicial assessor slumps nearby and a caricatured Jewish elder, with clasped, griping hands, stands anticipating Paul's conviction. However, as the caption of the engravings makes clear, Paul's words have a disabling effect on Felix, forcibly reminding the governor of his own sinfulness and guilt: as the saint 'reasoned of righteousness, temperance, and judgement to come, Felix trembled'. Around this

And as he reasoned of righteousness, temperance, and Judgment to come, Felix trembled
Engraved by W.^m Hogarth from his Original Painting in Lincoln's Inn Hall · *and Publish'd by him Feb.^y the 5. 1752.*

111

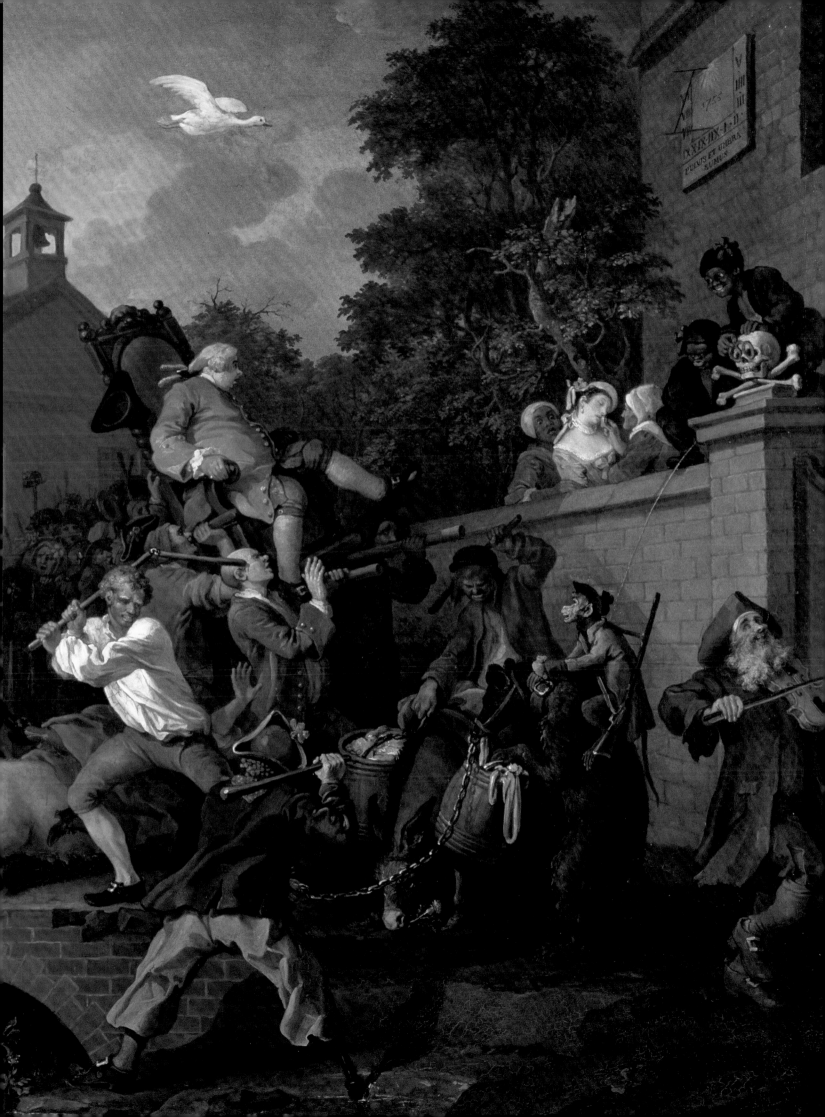

10
Patriotism, Portraiture and Politics

Mark Hallett

In May 1761 Hogarth submitted a selection of his works to a public display of paintings and sculpture mounted by the newly formed Society of Artists.[1] The display, held in the Society's 'Great Room' at Spring Gardens, was one of the earliest public art exhibitions ever held in England, and presented the artist with new opportunities and challenges.[2] In the Great Room his paintings – for the first time in his career – hung alongside scores of pictures produced by a wide variety of contemporary artists, and were looked at and judged by a broad urban audience that included not only connoisseurs, fellow-painters and newspaper critics but also the thousands of Londoners who were willing to pay the shilling admission charge. Hogarth, typically, made sure that he enjoyed a central role in the Spring Gardens display. He produced two illustrations for the catalogue and, with seven substantial paintings, was the chief contributor to the exhibition. Two of these canvases, *Sigismunda* (no.111) and *The Lady's Last Stake* (no.83), reasserted his credentials as a history painter and as a satirical commentator on high society respectively. Meanwhile, the five other pictures that he chose to send to Spring Gardens – *O The Roast Beef of Old England* (no.112), three portraits and *An Election Entertainment* (no.120) – showcased the different directions in which his art had developed from the late 1740s onwards. In particular, they confirmed Hogarth's increasing interest in nationalistic subjects, his dramatic resurgence as a portraitist and his new focus on political satire.

The oldest of the pictures sent by Hogarth to the exhibition flaunted his credentials as a patriot artist. *O The Roast Beef of Old England* ('The Gate of Calais') of 1748, which had been produced soon after a long, bitter and inconclusive war with France, famously depicts French society in the most jaundiced of terms. The xenophobic character of *O The Roast Beef of Old England* was nothing new of course: in works like *Marriage A-la-Mode* (no.77) the artist had already offered a savage indictment of the effects of French culture on elite English society. Here, however, he focused much more explicitly on French society itself, and on the mythical English alternative symbolised by the great hunk of sirloin being carried across the centre of the picture. The exhibition of *O The Roast Beef of Old England* at Spring Gardens – at a time when France and Britain were again at war – helped secure Hogarth's late, self-

cultivated and enduring reputation as a quintessentially 'English' artist, a reputation that had been reinforced by such works as *The March to Finchley* of 1749 and the *Invasion* prints of 1756. Significantly, a poem devoted to *O The Roast Beef of Old England* published during the Society of Artists display used the painting to reassert a myth of England as a place where, unlike France,

> health and plenty cheerfully
> unite;
> Where smiling freedom guards great
> George's throne,
> and chains, and racks, and tortures
> are unknown.[3]

Hogarth also exhibited three portraits at the Society of Artists exhibition. We know that one depicted his old friend John Hoadly; the other two remain unidentified. Despite the paucity of information about these works, their presence at the exhibition suggests the extent to which Hogarth, in the last decade of his life, returned to the sphere of portraiture. Indeed, in 1757 the artist had released a newspaper statement declaring that he intended to 'employ the rest of his Time in PORTRAIT PAINTING chiefly'.[4] While he was soon to chafe at this self-imposed restriction and engage in other kinds of art, Hogarth's declaration confirms his determination to succeed once again in a pictorial genre that, in this period, was being revitalised by a new generation of ambitious artists, including Joshua Reynolds and Thomas Gainsborough. Hogarth's late portraits, which include such dazzling images as his *Heads of Six of Hogarth's Servants* (no.116) and such unusual works as *Sir Francis Dashwood at his Devotions* (no.119) and *Francis Matthew Schutz in his Bed* (no.118), reveal the ways in which he continued to stretch and adapt the conventions of this most conservative of art forms.

The artist's final submission to the Spring Gardens exhibition – *An Election Entertainment* – illustrates the increasing interest he took in political subjects in the later years of his career. Up until the middle of the century, with the exception of handful of prints made in the 1720s, Hogarth had rarely ventured into the field of political satire, preferring instead to concentrate on the social satires that had first brought him fame. The *Election* series of 1754, of which *An Election Entertainment* was a part, signalled a new kind of artistic venture on his part, offering as it did a complex satirical

indictment of modern electoral corruption, and a detailed critique of the Whig and Tory party machines. This turn to political subject matter was to become more pronounced and controversial in the years that immediately followed the Society of Artists exhibition. The publication of *The Times* (no.124–5), *John Wilkes Esq.* (no.126) and *The Bruiser* (nos.129–31) saw Hogarth becoming actively involved in an increasingly bitter, personalised and politicised war of images and texts, in which the artist came under sustained attack for having entered into what his greatest critic, John Wilkes, called 'the poor politics of the faction of the day'.[5]

Wilkes's assault on the artist alerts us to the increasingly polarised responses Hogarth was attracting in the final decade of his life. For even as he continued to experiment and break new ground in his work, and to garner European-wide acclaim, he was also becoming the target of increasingly vitriolic attacks on both his art and character. By the time he died, three years after the Society of Artists exhibition closed, Hogarth was both the most celebrated and most vilified artist in Britain. It is perhaps no surprise, then, to find that his last work, *The Bathos* (no.134), is also one of his darkest, steeped in melancholy and self-doubt.

112

O The Roast Beef of Old England
('The Gate of Calais') 1748
Oil on canvas
78.8 × 94.5
TATE. PRESENTED BY THE DUKE OF
WESTMINSTER 1895

In the summer of 1748, during an armistice that followed the War of the Austrian Succession, Hogarth and a group of fellow-artists travelled to Paris. Hogarth, in his later account of the trip, declared that he was shocked by what he had found: a society in thrall to the 'farcical pomp of war' and distinguished by a 'parade of religion and bustle with very little business'.[6] Together with his friend Francis Hayman, he decided to head back to Britain earlier than the rest of the group. While waiting in Calais for a boat home, Hogarth sat down to sketch the old city gate, built by the British during their occupation of the city and still bearing the English coat of arms. Suddenly, he was seized by a French soldier and 'carried to the governor as a spy'.[7] Having convinced his suspicious captors that he was an artist rather than a secret agent, he was summarily despatched to England, 'where I no sooner arrived but set about a picture'.[8] The resultant painting, which famously dramatises his uncomfortable visit to France, offers a particularly acidic form of pictorial revenge on his recent hosts.

Hogarth's point of view is that of someone standing in an archway of the city's outer wall – and here he may have been adapting a pictorial device used regularly by the Italian artist Antonio Canaletto, then resident in London. From this shadowed, suggestively surreptitious vantage point, we look out at a scene dominated by the dramatic silhouette of Calais Gate itself, and loaded with xenophobic detail. At the centre of the image a French cook buckles under the weight of an English sirloin steak, destined for an inn catering to visitors from across the Channel. A contemporary poetic commentary on the painting gleefully noted the cook's 'hungry look', and the gesture of the corpulent local friar who, with a 'greedy eye' and lolling tongue, 'the solid fat his finger pres'd'.[9] Two soldiers in the French army, the smaller of whom is actually an Irish mercenary, break off from sipping the meagre gruel that has just been doled out from the 'kettle' being carried away, and gape at the appetising but unattainable food passing in front of their eyes. Nearby, a fugitive Scottish Jacobite clasps his hands together in despair while eating what Hogarth described as the 'scanty' fare typically found in France: a raw onion and a stale hunk of bread.

On the other side of the image a ragged French sentinel is similarly distracted by the sight of the sirloin, and, skulking in the shadows, a clutch of fishwives are cackling together over the marked resemblance they have discerned between a ray-fish and the friar's gluttonous face. Most famously of all, Hogarth inserts what he describes as 'my own figure in the corner' – a portrait, he sardonically notes, that 'is said to be tolerably like'.[10] Through the gate a procession of Catholic priests is seen carrying a cross through the streets. Their glimpsed presence, together with the soldier's hand that, unseen by the pictured artist, slyly reaches out to grasp his shoulder, provides a final reminder of the religious and military tyranny that, to Hogarth's eyes at least, had turned France into a land of 'poverty slavery and insolence'.[11]

Paul Sandby (1731–1809)
Four prints from *Twelve Cries of London Done from the Life, Part 1st* 1760
Etching
Title-page, 33.5 × 28
'Fun Upon Fun, or the first and second part of Mrs Kitty Fisher's Merry Thought [& etc.]' 28 × 21.5
'Rare Mackarel Three a Groat/ Or Four for Sixpence', 27.8 × 21.3
'Will your Hounour buy a Sweet Nosegay/ or a Memorandum Book', 23 × 17
MUSEUM OF LONDON
London and Madrid only
Fig.29

Credulity, Superstition and Fanaticism: Enthusiasm Delineated (first state) c.1760
Etching and engraving
37.5 × 32.6
THE BRITISH MUSEUM, LONDON
London and Madrid only
132

Credulity, Superstition, and Fanaticism: A Medley (third state) 15 March 1762
Etching and engraving
38 × 32.9
ANDREW EDMUNDS, LONDON
London and Madrid only
133

The Times, Plate 1 (third state) 7 September 1762
Etching and engraving
24.7 × 30.8
ANDREW EDMUNDS, LONDON
London and Madrid only
124

The Times, Plate 2 (first state) c.1762–3
Etching and engraving
Cut to 25.4 × 31.3
ANDREW EDMUNDS, LONDON
London and Madrid only
125

The Bruiser (first state proof) 1763
Etching and engraving
33.7 × 26.4
ANDREW EDMUNDS, LONDON
London and Madrid only
129

The Bruiser, C. Churchill (second state) 1 August 1763
Etching and engraving
37.7 × 28.5
ANDREW EDMUNDS, LONDON
London and Madrid only
130

The Bruiser, C. Churchill (sixth state) October 1763
Etching and engraving
37 × 28
ANDREW EDMUNDS, LONDON
London and Madrid only
131

John Wilkes Esq. (first state) 16 May 1763
Etching with engraving
35.5 × 22.9
ANDREW EDMUNDS, LONDON
London and Madrid only
126

Simon, Lord Lovat (second state) 25 August 1746
Etching with engraving
36.3 × 23.5
ANDREW EDMUNDS, LONDON
London and Madrid only
127

Tail Piece or *The Bathos* 1764
Etching and engraving
31.8 × 33.7
ANDREW EDMUNDS, LONDON
London and Madrid only
134

David Hockney (born 1937)
A Rake's Progress 1961–3
Sixteen prints, etching and aquatint
Each approx. 30 × 40
Plate No.1. The Arrival
Plate No.1a. Receiving the Inheritance
Plate No.2. Meeting the Good People (Washington)
Plate No.2a. The Gospel Singing (Good People) (Madison Square Garden)
Plate No.3. The Start of the Spending Spree and the Door Opening for a Blonde
Plate No.3a. The Seven Stone Weakling
Plate No.4. The Drinking Scene
Plate No.4a. Marries an Old Maid
Plate No.5. The Election Campaign (with Dark Message)
Plate No.5a. Viewing a Prison Scene
Plate No.6. Death in Harlem
Plate No.6a. The Wallet Begins to Empty
Plate No.7. Disintegration
Plate No.7a. Cast Aside
Plate No.8. Meeting the Other People
Plate No.8a. Bedlam
TATE. PURCHASED 1971
London and Madrid only
9

David Hockney (born 1937)
Programme cover for the Glyndebourne Festival Opera production of The Rake's Progress 1975
Offset lithography on paper
30 × 25
TATE LIBRARY AND ARCHIVE
Madrid only
10

David Hockney (born 1937)
Poster for the San Francisco Opera production of 'The Rake's Progress' 1982 featuring Hockney's design for the 'Bedlam' scene
Ink on paper
99.1 × 86.4
PRIVATE COLLECTION
Madrid only
11

Yinka Shonibare (born 1962)
Diary of a Victorian Dandy 1998
11.00 hours
14.00 hours
17.00 hours
19.00 hours
03.00 hours
C-type photographic prints
Each 183 × 228.6
COLLECTIONS OF PETER NORTON AND EILEEN HARRIS NORTON, SANTA MONICA. COURTESY OF STEPHEN FRIEDMAN GALLERY, LONDON AND JAMES COHAN GALLERY, NEW YORK
13

Paula Rego (born 1935)
The Betrothal: Lessons: The Shipwreck, after 'Marriage a la Mode' by Hogarth 1999
Pastel on paper on aluminium
Overall display 165 × 500
TATE. PURCHASED WITH ASSISTANCE FROM THE NATIONAL ART COLLECTIONS FUND AND THE GULBENKIAN FOUNDATION 2002
London and Madrid only
12

Lenders and Credits

Index

Ramsay, Allan 159; no.90
Raphael no.132
 Cartoons no.108
Ravenet, Simon François
 Marriage A-la-Mode engravings no.78
Rawlings, Nan no.101
realism 24
Rego, Paula 37
 Abortion Series no.12
 The Betrothal: Lessons: The Shipwreck, after 'Marriage a la Mode' by Hogarth no.**12**
Rembrandt van Rijn nos.110, 132
 The Artist in his Studio no.8
Restout, Jean no.73
Reynolds, Sir Joshua 35, 197–8, 215; nos.63, 117
 Discourses 34
Ribeiro, Aileen no.3
Rich, John 16; nos.1, 18, 38, 44
Richardson, Jonathan
 Essay on the Theory of Painting 26; no.92
 Explanatory Notes on Paradise Lost no.103
 on portraiture and history painting 159–60
 Two Discourses no.5
Richardson, Samuel 27, 28
 Clarissa 24
 Pamela: or, Virtue Rewarded 24, 141–2; nos.77, **79**, 82–3
Richmond, Duke and Duchess of no.53
Rochester, John Wilmot, 2nd Earl 75; no.40
Rock, Dr Richard nos.43, 67
Rococo style 142; nos.73, 76, 77
Rogers, Captain Woodes no.47
Roman Catholicism 24; nos.112, 113, 114, 132–3
Roubiliac, Louis-François no.3
 William Hogarth no.**2**
Rouquet, Jean André nos.73, 89
 The Present State of the Arts in England 159; no.3
 William Hogarth (attributed) no.**3**
Royal Academy 34, 35
Royal Cockpit no.101
Royal Society 24; no.85
Royalty, Episcopacy and Law no.**24**

S
Sacheverell, Dr no.43
Sadler's Wells no.67
St André, Nathaniel no.25
St Bartholomew's Hospital 17, 172; nos.1, 97, 102
St George's, Bloomsbury no.98
St Giles *see* St Giles-in-the-Fields
St Giles-in-the-Fields nos.67–8, 98, 99
St James's Palace 119
St Martin-in-the-Fields 119; nos.72, 98
St Martin's Lane 15
St Martin's Lane Academy 15–16, 17, 20, 56, 159; nos.1, 2, 5, 73
St Paul's Cathedral nos.5, 15, 61, 108; fig.40
St Paul's, Covent Garden no.58, 67–8
Salter, Elizabeth no.89
Salter, Revd Samuel no.89
Sandby, Paul
 The Analyst Besh[itte]n: in his own Taste 20; no.**7**
 London Cries: 'Last Dying Speech and Confession' 182; fig.36
 London Cries: 'Rare Mackarel Three a Groat Or Four for Sixpence' nos.61, 63; fig.29
Sandwich, John Montagu, 4th Earl no.119
Sarah Malcolm 182; no.**95**
Satan, Sin and Death (A Scene from Milton's 'Paradise Lost') 35; nos.4, **103**, 104
Satire on a False Perspective no.11
satirist, Hogarth as 15, 33, 34–5, 55, 56, 119, 198, 215; nos.1, 4, 84, 128
A Scene from 'The Tempest' no.**104**
Schutz, Francis Matthew no.118
Scotin, Gérard Jean-Baptiste nos.45–6, 78
 Marriage A-la-Mode engravings no.78
Self-Portrait with Palette no.**1**
self-portraits nos.1, 4, 8, 112, 134
Senesino, Il (Francesco Bernardi) nos.19, 44, 72
serial works 16, 18–19, 25, 28–9, 73–5; no.67
servants, depictions of nos.54, 55, 116
 black servants 142; nos.74, 77, 104
Seven Years War 215; nos.114–15, 124
Shaftesbury, Anthony Ashley-Cooper 3rd Earl no.5
Shakespeare, William 56; nos.4, 18, 65
 Antony and Cleopatra no.4
 Henry IV, Part 2 no.37
 Richard III nos.4, 105
 The Tempest 17; no.104
 The Tragedy of Richard III nos.105–6
Sheppard, Jack 182; no.96
Shonibare, Yinka 37
 Diary of a Victorian Dandy no.**13**
 The Swing (after Fragonard) no.13

shop cards
 Ellis Gamble's no.**15**
 Hogarth's no.**14**
The Shrimp Girl 33, 37; no.**63**
 detail 32
Sickert, Walter
 The Camden Town Murder 23; fig.6
Sigismunda Mourning over the Heart of Guiscardo 20, 198, 215; nos.**111**, 132
Simon, Lord Lovat no.**127**
singerie nos.74–5
Sir Francis Dashwood at his Devotions 215; no.**119**
The Sleeping Congregation no.132; fig.43
Smithfield Market 15
Smyth, Dr Arthur no.54
Soane, Sir John
 collection 36
Society of Artists 20, 215, 216; no.111
Soho 119; nos.67–8
Soldi, Andrea
 Edmund Gibson, Bishop of London no.92; fig.35
Solkin, David 21, 25, 26, 95
Somers, Lord 25
South Sea Bubble 55; nos.16, 18, 20, 22, 24
The South Sea Scheme 55; nos.**16**, 18, 20
Southwark Fair (or The Humours of a Fair) 27–8, 36, 120, 121; nos.5, 60, 63, **65**, 69
 subscription ticket no.64
The Spectator journal 24, 25; no.70
Spitalfields no.97
Steele, Richard 28; nos.1, 70
Steen, Jan no.123
Sterne, Laurence
 Tristram Shandy 25
Strand 15
Stravinsky, Igor
 The Rake's Progress no.11
Strode, Colonel Samuel no.54
The Strode Family 27; nos.**54**, 55, 56, 87
 detail 94
Strode, William 96; no.54
Strolling Actresses Dressing in a Barn 119, 120; nos.63, **69**
Stuart dynasty 24; nos.59, 67, 73, 113
Suarez, Michael no.4
The Sublime Society of Beefsteaks no.1
Sullivan, Luke nos.107, 109
Surgeons, Company of 182; no.99
Swift, Jonathan 120–1; nos.4, 67
 'Description of a City Shower' 120
 'Description of the Morning' 120
 A Tale of a Tub no.4
 Travels into Several Remote Nations of the World (Gulliver's Travels) nos.4, 26
Sympson, Joseph, Jr.
 The Christening (after Hogarth) no.35
 The Denunciation (after Hogarth) no.35
syphilis 74, 141, 142; nos.43, 67, 69, 77

T
tableaux de mode nos.40–2, 67, 76
Tail Piece or *The Bathos* 126; no.**134**
les talons rouges nos.76, 77
Taperell, John
 'The Art of Conversation' no.50
Taste in High Life nos.67, **74**, 76
The Tatler journal 24, 25; no.70
Taylor, George no.99
Tempest, Pierce no.60
Teniers, David, the Younger no.74
theatre
 Hogarth's links with 16, 33, 56, 181–2; nos.1, 4, 37–9, 73
 Licensing Act (1737) no.69
 Sadler's Wells no.67
Thomas Herring, Archbishop of Canterbury 18, 160; no.**92**
 detail 161
Thornhill, James 16, 17; no.8
 Jack Sheppard 182; no.96
 Paul before King Agrippa fig.40
 Portrait of Christopher Wren no.84; fig.34
Thornhill, Jane *see* Hogarth, Jane
Thornhill, John no.8
The Times 20, 216
 Plate 1 nos.**124**, 126, 128
 Plate 2 nos.**125**, 126
Tofts, Mary nos.25, 133
toilette nos.77–8
Tonson, Jacob nos.1, 4
Tories 216; nos.120–3
Tottenham Court Turnpike no.113
Troy, Jean-François de no.40
 After the Ball no.76
 Before the Ball no.76

The Declaration of Love 142; no.**76**
 The Game of Pied-de-Boeuf no.76
 The Rendezvous at the Fountain no.76
Truchy, Louis no.82
Trump nos.4, 128–31
Trusler, John
 Hogarth Moralised 21
Tyburn 119, 182; nos.77, 97
Tyers, Jonathan no.2

U
Uffenbach, Zacharias Conrad von no.60
Uglow, Jenny no.8
unity of action, concept of 28
urban scenes 119–21, 198; nos.63–72

V
van Aken, Joseph 26; no.58
Van Dyck, Anthony 25, 159; nos.1, 69, 90, 94
 portrait of Archbishop Laud no.92
 Rachel, Countess of Southampton, as Fortune no.69
Van Gogh, Vincent 23
Van Loo, Jean-Baptiste 159, 160
Vanbrugh, John 25
 The Relapse, or Virtue in Danger 74
Vanderbank, John 16
Vandergucht, Gerard
 Don Quixote Takes the Puppets to be Turks and Attacks them to Rescue Two Flying Lovers (after Coypel) no.**23**
Vauxhall Gardens no.2
Veil, Sir Thomas de no.67
venereal disease *see* syphilis
Vernet, Claude-Joseph
 Four Times of Day no.67
Verrio, Antonio no.84
Vertue, George 13, 26, 73, 95, 96; nos.1, 2, 35, 105
Voltaire 25; no.4

W
Wagner, Josef
 Golden Pippins (after Amiconi) nos.**61**, 63
 Shoe-Black (after Amiconi) nos.**62**, 63
Wales, Frederick, Prince of no.56
Walpole, Horace 34, 198; no.56
 Anecdotes on Painting in England 33
Walpole, Sir Robert 25; nos.26, 56, 69
Wanstead House no.48
War of the Austrian Succession no.112
Ward, Edward Matthew
 Portrait of Thomas Coram in Hogarth's Studio 37; fig.15
Ward, Edward 'Ned' 121
 A Walk to Islington 119
 The London Spy 119–20, 121; no.70
 The Merry Travellers 119
 The Poet's Ramble after Riches no.70
Ware, Isaac no.2
Watteau, Antoine 26; nos.40, 74, 76
Webster, Mary 21; nos.47, 84, 91, 93
Wendorf, Richard no.94
West End 15, 16, 18
The Western Family no.**55**
Western, Thomas no.55
Wharton, Duke of nos.22
Wheatley, Francis no.63
Whigs 25, 216; nos.26, 120–3
Whistler, James McNeill 33, 37
 The Chelsea Girl 33
 Wapping 33; fig.10
Whites' gambling house no.44
Whittington, Richard 'Dick' 182; no.97
wigs no.3
Wilkes, John 20–1, 216; nos.124, 126, 128
 The North Briton no.126
Wilkie, David 36
 Chelsea Pensioners Reading the Waterloo Dispatch 33, 36
 The Village Holiday 36; fig.13
William III of Orange (King William III from 1689) 26; no.73
William Jones nos.**85**, 86
Wills, John 19
Winnington, Thomas no.56
Wollaston, William 96; fig.7
The Wollaston Family 26; fig.7
Woodes Rogers and his Family no.**47**
Wootton, John
 The Monkey Who had Seen the World no.**75**
Wren, Sir Christopher
 Sheldonian portrait no.84; fig.34